MANGA CLIP ART

CREATE YOUR OWN PROFESSIONAL-LOOKING MANGA ARTWORK

D0573993

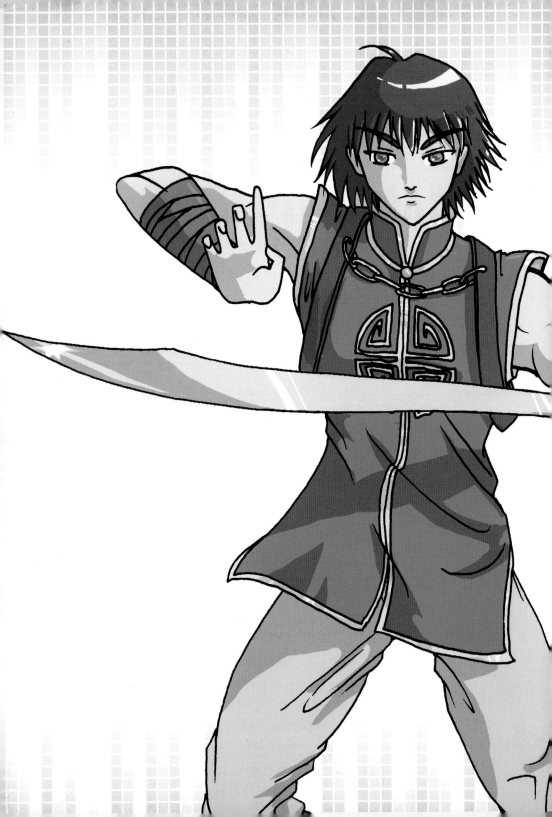

MANGA CLIP ART

CREATE YOUR OWN PROFESSIONAL-LOOKING MANGA ARTWORK

HAYDEN SCOTT-BARON

ILEX

Manga Clip Art
First published in the United Kingdom in 2012 by

I L E X

210 High Street
Lewes
East Sussex
BN7 2NS

Publisher: Alastair Campbell
Creative Director: James Hollywell
Managing Editor: Nick Jones
Senior Editor: Ellie Wilson
Commissioning Editor: Tim Pilcher
Art Director: Julie Weir
Designer: Simon Goggin

British Library Cataloguing-in-Publication Data
A catalogue record for this book is available
from the British Library.

ISBN: 978-1-908150-23-3

Printed and bound in China

Colour Origination by Ivy Press Reprographics

10 9 8 7 6 5 4 3 2 1

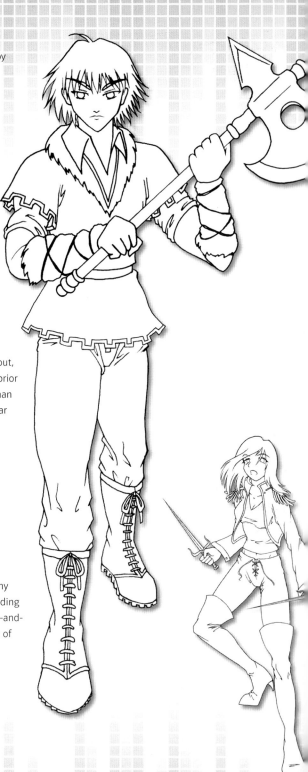

CONTENTS

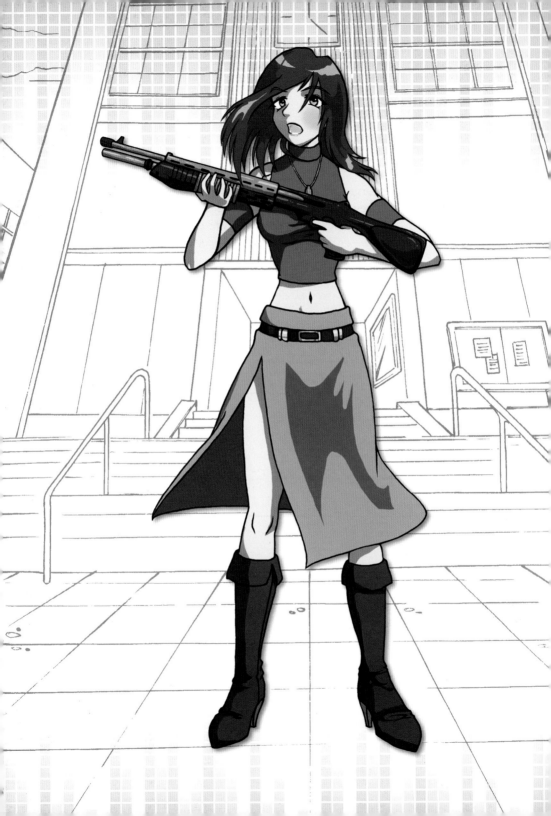

INTRODUCTION

Having existed in its present form for a mere fifty years, manga might at first glance seem like a relatively new art form. However, the roots of this "contemporary" art can actually be traced back as far as the nineteenth century. At that time, ukiyo-e was emerging, a form of Japanese print made with blocks carved from wood. One of the most prevalent artists of this period was Hokusai. His iconic images, so representative of Japanese art of the time, showed scenes of daily life involving men, women, and animals. It was Hokusai himself who coined the term "manga," which has been literally translated to mean "whimsical pictures," "involuntary sketches," and even "irresponsible pictures." Under the influence of Western comic styles, the ukiyo-e art form evolved to become what we now regard as modern-day manga. Hokusai would make way for Tezuka, whose early creations (such as Astro Boy) have often been named as the true beginnings of what we now know as manga.

Manga's massive appeal today is often credited to the sheer breadth of its content. Modern manga will tell stories of the fantastical, the futuristic, the romantic, and the humdrum. The wealth and variety of the stories and styles mean that manga can provide something for everyone. Whatever your age or interest, there will be a series out there for you.

Moving from history to the present day, the book you now hold in your hands is your introduction to the world of manga. Tutorials in the first half of the book provide you with some quick and easy steps to launch you into manga character design and illustration. Though manga is a fun and diverse form that relies largely on your own creativity, it never hurts to know a few basic rules before starting out. From simple structure to color theory, this book will see you on your way. Whether you are a newcomer to the vast world of manga artwork or an experienced artist looking to try something different, this book will provide you with the foundations that you need. And, of course, there's the accompanying CD. By using the line-art images included on the CD and following the simple step-by-step instructions, you will be able to create full-color manga pictures with ease.

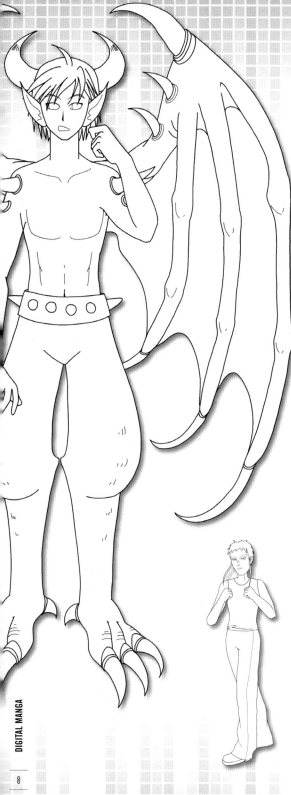
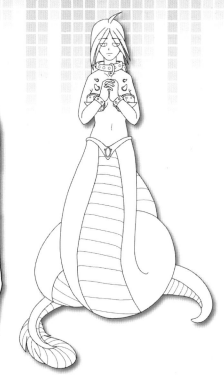

On the CD you will find a variety of characters and accessories. Whether you are an experienced artist or someone trying their hand at manga design for the first time, there will be something here for you. We have done most of the hard work for you, so you will be able to create your own characters in a matter of minutes. It's as simple as selecting the look you want, assembling the sections of line-art you like, and throwing in a splash of color!

You can use the provided illustrations as building blocks to create your own characters and then add color digitally via your computer. Or you can print off your linework and use inks, pencils, or paints to bring your pictures to vibrant life. The CD enables you to create an assortment of characters ranging from heroic fighters to terrifying monsters, with a huge variety of faces, bodies, and accessories to fully customize your design. A vast array of possibilities lies ahead of you: You can design men, women, machines, angels, demons, and a whole host of other characters.

You are only limited by your imagination!

ON THE DISC

TAKING IT FURTHER

There's no need to feel constrained to using the line-art provided on the disc. In time, you may find that you have your own ideas for characters. Perhaps you will have an accessory in mind that is not on the CD. You can use your experience with this package as a guide to creating your very own designs. Incorporate your own line-art with the images provided on the CD to give you even more variety. When you feel confident enough, you may even want to create an entire cast of characters and go as far as putting them into your very own manga story. Either way, you will be able to use this package to gain experience and insight into how a manga character is put together. Enjoy yourself and apply your creativity to what has been provided and you're on your way.

ACCESSORIES
Over 120 accessories for male or female characters. There are instructions for using them on page 23, and they are shown on pages 126–127.

BACKGROUNDS
Six fantastic backdrops on which to place your newly created manga characters (see pages 120–125).

CHARACTERS
The meat of the disc—19 characters provided as Photoshop-compatible layered PSD files. By turning layers on and off (see pages 20-25) you can create literally millions of different combinations.

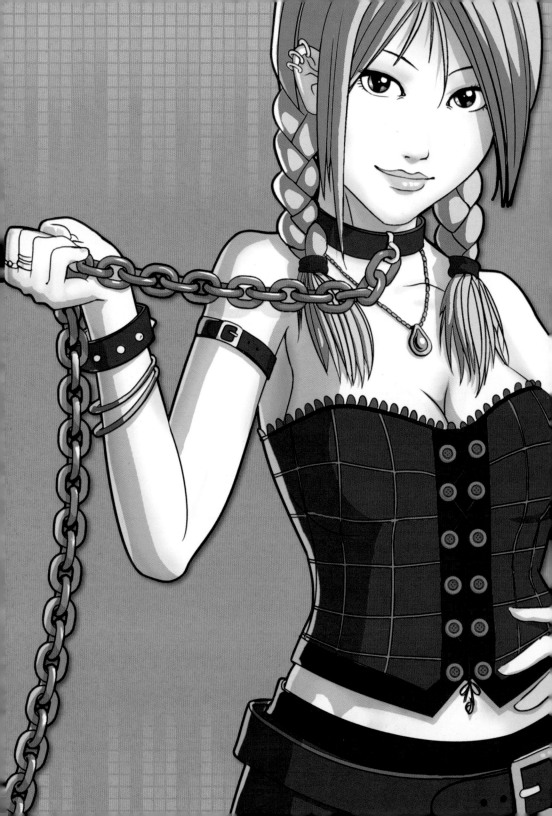

DIGITAL MANGA

INTRODUCTION TO DIGITAL ART

The use of computers in the production of art has revolutionized the way artists work and has made it very easy to create professional-quality images. Fast and powerful computers are already a fixture in many households, and art-focused peripherals have become incredibly popular. This, combined with the improvements in software, has made it easier than ever before to create fantastic manga artwork.

Computers are capable of many things—storing your music library, editing your videos, and, most significantly from our perspective, editing images. There has been a great deal of development in that field in recent years, and we can use the results—powerful applications like Photoshop—to our advantage. You may already have access to most, if not all, of the equipment shown. If not, it can all be acquired relatively cheaply. Even Photoshop itself is available in a cut-down form called Photoshop Elements.

For the purposes of this book, everything can be achieved with this significantly less expensive program. Elements will also show you the color-coded layers we've used to make the creation of manga characters as easy as possible, though it won't let you change the color codes. From a professional perspective, the full version's CMYK facilities and masking tools are invaluable, but at home you'll just be able to draw, color, and have fun with either program.

GRAPHICS TABLET

Although it takes a little practice, it's much easier to draw and color on a computer if you're using a graphics tablet. Many different brands and types of tablets are available. When buying a tablet, consider the software that is bundled with it, and whether or not the pen requires batteries. Although some popular brands can be more expensive, their quality and reliability can more than justify the cost.

MOUSE

Every computer has a pointing device, but it is worth making sure you have a good one if you intend to use it for artwork. Ideally, you should use a laser- or LED-based mouse. These are much more precise than traditional ball-based mice, and won't jam or become slow. Their other advantage is that they don't require such frequent cleaning to operate reliably. The only drawback is that they can be a bit picky about the surface they operate on.

INKJET PRINTER

Color printing is now very cheap and high quality, and it's certainly worth buying a color inkjet to see your creations on paper. Even relatively cheap printers are able to create good quality prints, and quality can be improved considerably with the use of photographic paper (so long as you set the appropriate options in your printer's software). It's worth knowing that certain colors will look different when printed than on a monitor. Many shades of purple will look different in print, as well as bright shades of blue and yellow, but your pictures will look great regardless of this small inaccuracy.

INTERNET

The internet has made it incredibly easy for artists to share their work. By publishing your artwork on the net, you can get immediate feedback and impressions from other manga enthusiasts. It's also possible to get advice and support when trying to improve your skills. Looking at other people's work can be both inspiring and informative when learning skills like computer coloring, and it's often possible to ask artists questions about how specific illustrations were made. Be sure to make the most of this great resource and allow the whole world to see your manga.

LASER PRINTER

Although laser printers—particularly the more affordable ones—are usually only black and white, they do have some advantages over inkjets. The lines are often crisper and the printing speed is significantly faster. Most importantly, the ink from a laser printer is waterproof and alcohol resistant. This means that printed pages can be handled without risk of being smudged by fingers, which is great for comic pages. It also means that it is possible to use markers to color in your characters, without risk of the ink smudging. Inkjet inks would mix with the pens and run (one way round this is to use a photocopy).

PHOTOSHOP AND PHOTOSHOP ELEMENTS

Photoshop has become the standard for digital art among both home users and industry professionals. Although the software was originally designed for use in photo manipulation, the variety of tools it offers makes it the perfect choice for illustration too. From an illustrator's perspective, and therefore that of a manga artist, Photoshop offers flexibility combined with the ability to handle very high-resolution images.

Photoshop comes in two versions: the classic image editor, now part of the powerful Adobe Creative Suite; and Photoshop Elements, a cut-down version for home use. Both are ideal for our purposes. Let's see why.

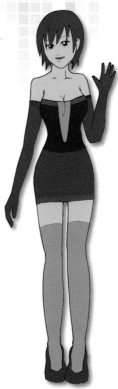

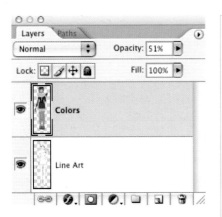

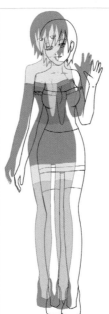

LAYERS

Layers are one of the most useful features of digital imaging. Imagine each layer is a piece of clear acetate with part of a picture drawn on it, creating the complete image only when the layers are stacked together. Because each layer can be manipulated independently, it is possible to work much more freely, without the risk of spoiling your artwork. You can use layers to experiment, simply turning them off if you don't like them, a process essential to building the manga characters on the disc.

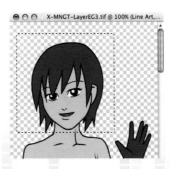

SELECTION AREAS

When working in Photoshop, selections are an important way to control which part of the picture is affected by your painting. A selection is outlined by "marching ants" and changes can only be made within it while it is active. You can define a selection using tools—for example, the Rectangular Selection tool draws a simple box, while the Magic Wand tool selects areas of similar color, whatever the shape. When you have finished with a selection you must remember to switch it off, or "deselect," or you will not be able to edit outside it.

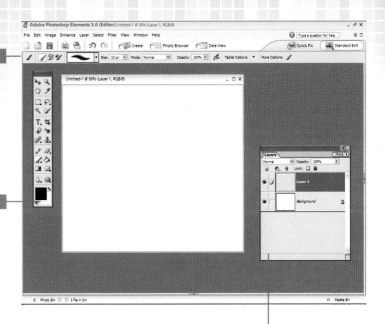

TOOL OPTIONS BAR

While the Toolbox provides access to many different functions, the Tool Options bar allows you to refine the selected tool. If you're using the Brush tool, for example, you can pick different size and texture brushes here.

TOOLBOX

Though they differ slightly, both versions of Photoshop have a Toolbox which, by default, appears on the left side of the window. (In Photoshop Elements it might also be docked to the side of the window as a long single column.)

PALETTES

Both versions of Photoshop equip you with a number of floating windows, known as "palettes." Perhaps the most useful is the Layers palette, where you can switch on and off the alternative elements in the projects supplied in this book. This is done by clicking in the box to the left of the layer. An eye logo indicates that the layer is visible, or "on."

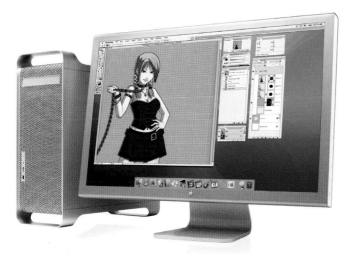

Adobe Photoshop shown running on an Apple Macintosh. If your computer has a large monitor, you'll find yourself with more room for your palettes. You can also zoom in and out of your image, but you should always check your artwork at 100%. This is because only at that size are the pixels in the file seen 1:1 with the pixels on your monitor. At other sizes, false pixels can create a less pleasing, and less accurate, simulation of the final printout.

PHOTOSHOP TOOLS

The Photoshop Toolbox is the centerpiece of your digital manga world. Without it you couldn't zoom in and out of creations, move your characters' accessories around, or paint them any color you wish. Here we'll have a quick look at the main tools in the Photoshop Elements Toolbox. (Photoshop itself has very similar tools, and the only ones we need to use appear in both versions of the program.)

Move

Click and drag to move the currently active layer or selection.

Hand

The Hand tool lets you pan (or scroll) the image around, making it possible to see different sections of the image.

Zoom

Using the Zoom control will let you enlarge and reduce the preview of your image. Holding Ctrl/Cmd and pressing the + and – keys will allow you to zoom in and out at any time.

Eyedropper

The Eyedropper tool selects any color you click on and makes it the foreground color (as shown at the foot of the Toolbox). Set the mode to "point sample" to ensure precise color picking. The Alt key has the same effect if you're using the Brush tool.

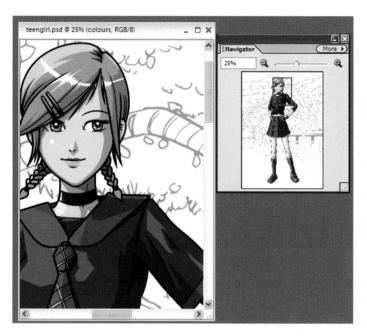

NAVIGATOR WINDOW

This window will enable you to move around your document quickly without using the Toolbox or keyboard. This is especially useful if you're using a graphics tablet and prefer to avoid using the keyboard.

NAVIGATION

The ability to move around a document easily is an important part of working digitally. Whether it's to focus on a different part of the body, or to zoom out and see the big picture, or simply to check the color of a different part—being able to get around the image quickly will help you to work more efficiently.

SELECTION

Accurate selections will help you create professional-looking artwork. There are several tool options to choose from

 Marquee tools

In both Rectangular and Elliptical form, these are the simplest selection tools, enabling you to highlight a simple rectangle or ellipse by clicking and dragging. Hold Shift as you do so for a perfect square or circle.

Lasso tools

These tools allow you to select any shape you wish. The Freehand Lasso allows you to quickly define a shape with the mouse, but it can be difficult to control precisely. The Polygonal Lasso creates a selection by drawing a series of points to define a shape.

Selection Brush

The Selection Brush allows you to "draw" the areas of selection directly onto the page. The Selection Brush is exclusive to Photoshop Elements, but Photoshop offers an alternative in the form of the Quick Mask feature, which allows other tools to be used to "paint" the mask.

PAINT TOOLS

The paint tools are used to draw lines and add color to an image. Different shapes and sizes of brush will affect the way the lines appear on the image. See page 18 for more information on brushes.

Pencil

A special variation of the Brush tool, creating pixel-perfect (or "aliased") lines. This is very useful for cel-style coloring (see page 32), since by default the computer tends to soften edges.

Paintbrush

The standard painting tool, useful for soft edges and smooth lines. This is a great coloring tool, and there are many stylistic options in the Tool Options bar.

 Dodge, Burn, and Sponge

These brush-like tools adjust the color in different ways. Dodge lightens the current color, while Burn makes the color darker and richer. These tools can offer easy ways to shade images, but most artists prefer to use layers and other methods of shading. The Sponge tool, on the other hand, absorbs the color and turns the image to gray.

Eraser

The Eraser deletes color from the currently selected layer. The Eraser works in exactly the same way as the Paintbrush, but removes the color instead of adding it.

Paint Bucket

This tool fills an area with a selected color or pattern, and is perfect for laying block colors on an illustration. Click on an area and it will be filled to its edges (the level of contrast required to define an edge is called "Tolerance"). To make a selection in this way, without filling, use the Magic Wand tool.

 Smudge, Blur, and Sharpen

These tools have no color of their own. Instead, the Smudge tool will smudge the colors around in the direction in which you move the cursor. Blur and Sharpen will alter the contrast of neighboring pixels to soften the definition, or increase the sharpness.

TIP

Holding the Shift key when using a selection tool will "add" your selection to the existing selection. Holding Alt will allow you to delete from the existing selection area. Look out for the + and − signs next to the mouse cursor. They indicate whether you'll be adding or subtracting from your selection.

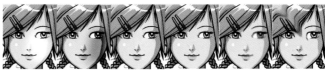

Dodge Burn Sponge Sharpen Blur Smudge

PHOTOSHOP BRUSHES

When you start drawing your own manga, or editing some of the creations on the CD accompanying this book, the Brush and Pencil tools will be your main allies. They represent the most basic method of adding lines and colors to an image. By changing the brush shape and other settings, you can set the Brush tool to be opaque like a paint, translucent like a marker pen, or even remove color like an eraser. The nib can be blunt like a piece of chalk, sharp like a pencil, or even vary in width like a paintbrush or nib pen. Learning how to easily change and control these settings will give you much more freedom when working in Photoshop or Photoshop Elements.

Photoshop File Edit Image Layer Select Filter View

Brush: 27 | Mode: Normal | Opacity: 100% | Flow: 100%

Brush
Choose the type of brush you want to use from this menu. Pressing < and > will cycle through the range of brushes available.

Size
This adjusts the size of the currently chosen brush. You can use the [and] keys to perform the same function.

Opacity
Opacity: 100%

Changes how transparent the ink or paint will be. 0% would make the paint completely invisible, 50% is half-transparent, and 100% is completely solid.

Airbrush
This changes the brush to Airbrush mode, which gives you a gradual flow of paint (depending on the Flow setting). Although this is useful, many people just use a soft brush instead.

BRUSH SHAPES

● Hard brush [1]
These brushes give you a solid shape and smooth outline. Although the edge is anti-aliased (softened), it is still sharp enough to give a convincingly hard line.

● Soft round [2]
These brushes have a gradient of density, and their opacity is reduced toward the edge of the basic shape. They are perfect for soft, airbrush-style coloring.

Natural brushes [3 + 4]
A selection of irregularly shaped brushes are available with the intention of emulating "natural media" such as paints, pastels, and charcoal. This style is covered later in the book (see page 44).

1

2

3

4

Master Diameter | 27 px

Use Sample Size

Hardness:

1
3
5
9

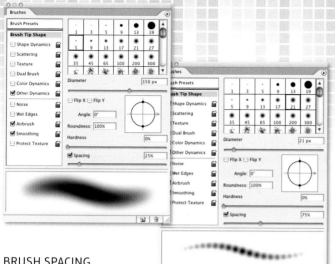

BRUSH SPACING

A simple setting in the Brushes palette, this can make a big difference in the quality of your lines, as well as the performance of your computer. By reducing the brush spacing, the dots will be drawn closer together, resulting in a smoother line (in most instances), and translucent areas of the brush will appear darker. However, as more dots will be drawn it also means that your computer will have to work harder. Also, when using a graphics tablet it is often crucial to decrease the spacing in order to avoid the line breaking when the pen is moved very quickly.

GRAPHIC TABLET PRESSURE SETTINGS

One of the biggest advantages of using a graphics tablet over using a mouse is the fact that the pen is pressure-sensitive. This allows you to change the way a Photoshop tool behaves, depending upon how firmly you press the tip of the pen against the tablet.

Usually you'll want to set the pressure control to Size when drawing inks and block colors, and to Opacity when shading or adding color.

Some more expensive tablets (such as the Wacom Intuos series) also allow for pen tilt recognition, which allows for additional settings to be adjusted relative to how close the pen is to being held vertical. This is a handy feature, but not as useful as the pressure control.

Quick Brush Resizing
The [and] (square bracket) keys allow you to quickly resize your brush (holding down the Shift key at the same time also alters the hardness). By making the most of this you can quickly adjust the level of detail you're working with. This is especially useful when using soft brushes to color your images.

Quick Color Changes
When working with the Brush or Pencil tools, you'll often want to change color quickly. By holding the Alt key and clicking over a pixel the color of your choice, you pick up that color from the canvas. (You might even want to keep a "palette" area of dabs of color on your image, until you're finished.) Also worth noting is the X key, which will alternate between your foreground color and background color.

Painting with Opacity Controls
The number keys along the top of the keyboard act as handy shortcuts for adjusting the opacity of your brush. Press 1 for 10% opacity, 2 for 20% opacity, etc. If you press 2 and 5 quickly, you will get 25% opacity. This is useful if you want to introduce subtlety to your coloring, but don't want to change color. These shortcuts combined with the X button can allow for very fast monochrome illustrating.

CREATING CHARACTERS

Building a character from the files supplied on the CD is simple, with numerous possibilities. Let your imagination run wild and be sure to experiment with lots of combinations. The files have been designed to be as flexible as possible, so mix and match to create the best manga characters you've ever seen.

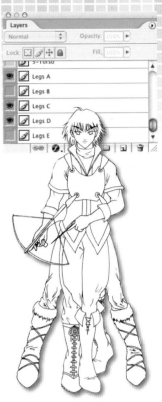

1 Insert the CD supplied with this book. It doesn't matter what kind of computer you're using—Mac or PC—you should find a folder labeled "Characters." Inside this you'll find a layered .PSD (Photoshop) file for each character type in this book. Go to File > Open in Photoshop or Photoshop Elements, then choose the character you want. The layers within the files act like a traditional animator's acetate films—all we need to do now is put the elements together to form a character. This process is achieved by turning the visibility of some layers on and off—their status is indicated by the presence of an eye to the left of the layer's name in the Layers palette.

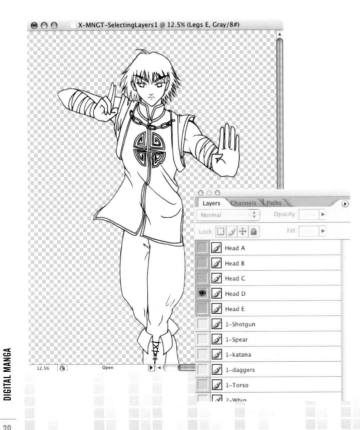

2 Turn to the corresponding pages of this book to see the options for your character, including a full listing of the layers available. To help you, the layers have been color coded, and generally you will not want to turn on more than one head, legs, or torso at once.

3 For many projects you'll be finished at this point. Simply click Layers > Flatten, then save the image onto your computer using File > Save As from the menu. You will not be able to save over the original file since it is on CD.

If, however, you find things just aren't right and want to customize your line-art further, then try the tricks on the next few pages to perfect your character.

4 With some of the more complicated characters, the variety of heads and bodies may not always line up precisely. In that case, choose the misaligned layer by clicking on it, select the Move tool, and either nudge the layer into place with the cursor keys or drag it with the mouse. Stop when you are happy with the new position.

5 Some combinations of clothing may require you to adjust the order of the layers. Alternatively, you may want to adapt the look by changing the layer order. For example, a T-shirt can be tucked into trousers by moving it behind (or below) the legs layer. Simply drag the layers up and down on the Layers palette to change the order.

6 Some character sets have facial expressions that can be adjusted in the same way. Simply choose a base and then decide which face to insert.

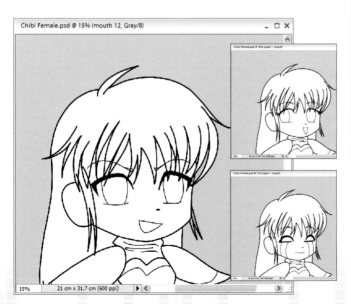

TIP

See more layers

To see more layers at once in the Layers palette, you can change the size of, or remove, the image preview. Simply click on the "More" arrow at the top left of the palette and choose Palette options. The larger the preview, the fewer layers will be visible at once.

MIXING COSTUME SETS

Many of the costume sets are designed to be compatible in terms of scale, so you can experiment with different combinations of costume sets. By interchanging parts from different sets, you can create some truly unique and diverse characters.

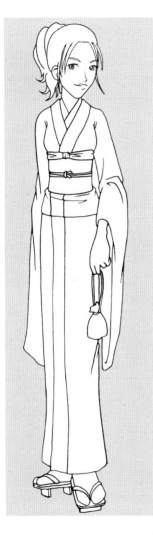

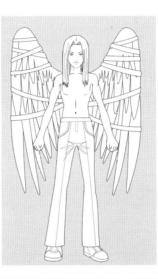

◄ *Parts from the Monster sets can look great on Contemporary characters as well.*

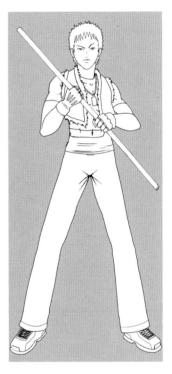

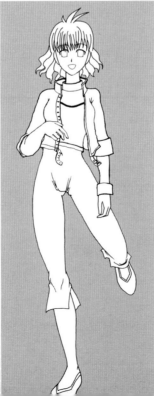

▲ *The pole-wielding torso was layered over the simple vest torso to create a cool "street" look.*

▲ *The Asian costume set is designed specifically to be combined with heads from other sets. Copy a head from the Warriors, Contemporary, Sci-fi, or Monster sets to fit on these bodies.*

◄ *Monster heads and Warrior legs (as shown here) can be made to look far less aggressive when combined with regular character parts.*

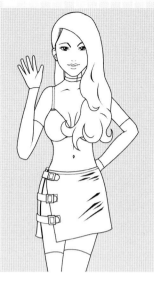

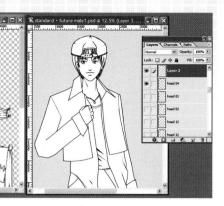

ADDITIONAL CLOTHING

The suggestion of additional clothing can be introduced to the characters with simple lines added to the character after construction. I think about how the final image will be colored, and areas that could suggest extra clothing or layering simply with the use of an extra line. You can also create new looks by erasing certain lines of existing artwork. Try some of these:

• Stockings
• Long socks
• Arm warmers
• Gloves
• Vests and tight clothing
• Collars and chokers

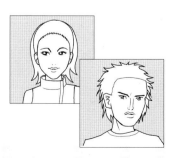

OVERLAYING HEADS

By overlaying different heads, you can introduce entirely new hairstyles to your characters. A character with longer hair can be placed behind a different head to create an entirely new look.

In the Contemporary female set, there are several additional hair sets designed for placing in front of or behind the existing hair to create entirely new looks.

USING ACCESSORIES

A large number of accessories are included in addition to the ordinary clothes in each set. These are mostly intended for the regularly proportioned characters, but some might also be of use on Chibi or Child characters.

1 Open up the accessories page and your target image alongside each other. Pick the accessory of your choice.

2 Using the Lasso tool, draw a rough selection around it— there's no need for accuracy but be sure to select the whole shape.

3 Using the Move tool, drag the shape onto your character.

4 All that remains is to drag the accessory into place. It will appear on its own layer, so use the Move tool to position it and the Edit > Free Transform tool to rotate or scale it to fit.

RESIZING, ROTATING, AND FLIPPING

Certain accessories, and even some heads, can look best by rotating or resizing them to fit the character. The only disadvantage of doing so is that by transforming the elements like this you will cause the image to become anti-aliased, which can cause problems when coloring. Be sure to remove anti-aliasing before you continue with the coloring.

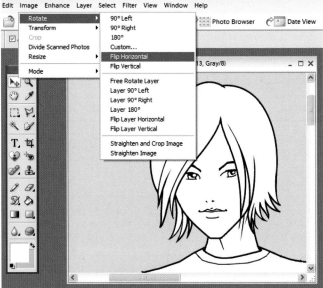

3 To scale the width and height proportionally, either press Shift as you drag a corner handle, or click the Maintain Aspect Ratio button in the options bar before dragging a handle. Avoid using the side handles, as these will stretch the object.

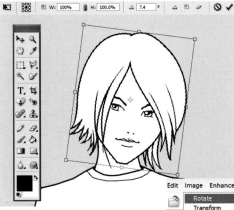

1 Select the layer you wish to adjust, so that it is both visible and becomes the active layer (its name is highlighted). Choose Alt + T (or Edit > Free Transform).

2 To rotate, move the pointer outside of the bounding box (it becomes a curved, two-sided arrow), and then drag. Hold Shift and drag in steps of 15°. When transforming you can move the object by dragging inside the transform box.

4 Flipping (or "mirroring") an image can be done by choosing Image > Rotate > Flip Horizontally from the menu.

5 When you have finished adjusting the image, press the enter key or the "tick/check" button on the right side of the toolbar.

PREPARING THE ARTWORK FOR COLORING

When you have completed your character, you should prepare it to be colored. It's important to flatten an image and make sure that no anti-aliasing is present.

Blurry, "anti-aliased" lines can be especially problematic during coloring. Anti-aliasing is the way lines are blurred on screen to make diagonal and curved lines look smoother. While this creates a great visual effect, it can cause problems when adding color. For example, the Paint Bucket tool will fill a white area until it comes to the edge of the next color—if that's light gray rather than black, it'll stop there.

You can compensate for this to some extent by using a high Threshold value in the Tool Options bar, but a better way is to remove all anti-aliasing and layers at this stage.

1 Choose Layers > Flatten Image from the menu. This will reduce the image to a single layer.

2 Choose Image > Mode > Bitmap. Leave the resolution as it is, but change the method to "50% Threshold." This means any colors above 50% darkness will become black, and any below will be white. (You will need to convert back to RGB mode before you can color.)

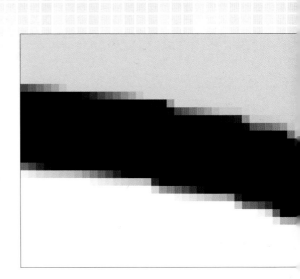

BLOCKING IN BASE COLORS

Once your line-art is prepared, the next step is to block in the base colors for your picture. Filling in base colors is the first and most important stage of coloring. The base coloring is where you decide the dominant shades you use in your picture, so think of the kind of mood you want to create. Do you want to use lots of soft, pale colors, or strong, bold hues? The colors you choose now will affect the shades you use for shading and highlights, no matter what coloring method you choose to follow afterward. These colors create a foundation, or in some cases can be all the picture needs to look complete.

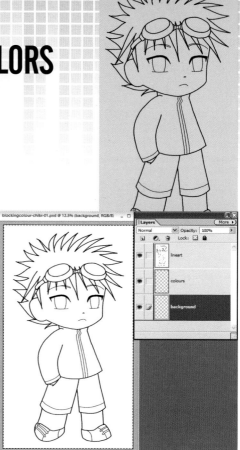

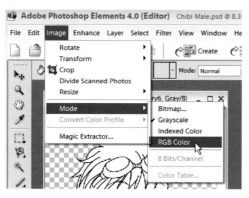

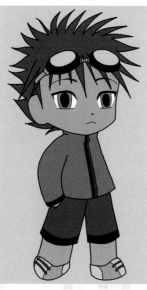

1 You might find that your line-art is in Monochrome or Grayscale mode. In either case, you will not be able to apply color or, if you do so, it will appear as a shade of gray. To solve this, click Image > Mode > RGB Color, which will give you a theoretical palette of 16.8 million colors.

2 Save your file somewhere on your own computer's hard disc using the File > Save As command.

3 Prepare your line-art by first copying it to a new layer. Set this layer's blend mode to Multiply. This will allow the colors on layers beneath to show through the layer above.

4 Create a new layer beneath the line-art layer, and keep the blend mode set to Normal. This will be used for colors.

5 Make a new layer and place it beneath the base color layer. Fill the entire page with a pastel color (light blues and greens are often best). This will make any gaps in coloring more obvious.

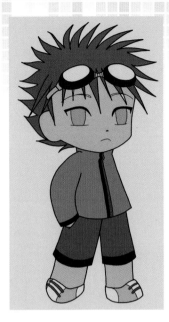

6 Choose the Paint Bucket tool, and make sure the settings have Anti-aliased unchecked, Contiguous checked, and Use All Layers checked. Set the Tolerance to a small amount (such as 32) so that neighboring color areas are not filled accidentally.

7 On the base color layer, use the Paint Bucket tool to color each section of the image. Color the larger areas first, like hair, skin, and clothes, leaving accessories and other extras until later. This way you can better complement the colors used on the clothes and hair with the accessories.

8 Now select the Pencil tool to begin adding detail. If there are any difficult to fill areas or small gaps in coloring, use the Pencil tool to color them carefully. Often eyebrows and strands of hair are problem areas.

TIP

Rapid color swapping with the X and Alt key
Most of the time when you are coloring, you will only be using two colors at a time. By using the X button to alternate between foreground and background color, you can have a "spare" color available at any time. Also, it's often worth using the Alt key to quickly pick up colors from other areas of the picture—this can help to make sure your picture is coordinated, and also minimizes the need for the Color Picker window.

9 Some parts of the image may not have each part of the body fully defined in the line-art. By using the Pencil tool you can add colors to the image very precisely, sectioning off parts of the picture or making areas more vivid.

10 Now your base colors are complete, you can begin to add shading to the image.

TIP

Quick color change

If you decide you don't like a color you've used, but you've already finished the base colors, you can still change it easily with the Fill tool. Uncheck the Contiguous box on the toolbox, and with one click you can replace the unwanted color with a different shade.

USING CONTIGUOUS TO SPEED UP COLORING

Some image areas can be quite complicated to color, with many small areas that would take a long time to fill in with a Brush or the Paint Bucket. The Contiguous setting in the Paint Bucket options can make this easier. By turning Contiguous off, you can fill entire areas with color very quickly, even though it will flood outside of the area you wish to color. Using the selection tool to choose small areas, you can use the Paint Bucket without Contiguous to fill an area, then turn Contiguous back on to correct where the color was not wanted.

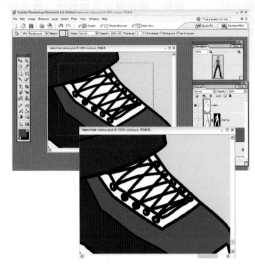

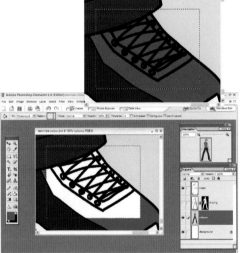

3 Turn Contiguous back on, and fix the excess white. This way we've avoided clicking between every contiguous shape in the shoelaces, and only clicked once to fill the larger blue area.

4 Select the center part of the laces. Since this is an angular shape, you could click at each corner of the target area with the Polygonal Lasso tool.

1 Select the rough area you wish to fill in using one of the selection tools—here I've used the Rectangular Selection tool.

2 Use the Paint Bucket with Contiguous unchecked to fill in the white.

5 With Contiguous unchecked, fill in the center. Only the selection will be filled.

CHOOSING COLORS

No matter how attractive your line-art, if you choose the wrong colors to go inside those lines, your image can be ruined. You should never forget how important your choice of color can be and the effect it can have on a piece in terms of composition, design, or mood.

One of the first choices you may come across when exploring image coloring is whether you should choose colors that are realistic and believable, or colors that simply look the part. Of course, in the world of manga, these lines can often become blurred. Take hair for example: in the context of manga, bright pink hair doesn't seem odd at all!

However, no matter how radical (or how realistic) your tastes, it's always helpful to know a little of the theory behind the color process. Certain colors will naturally complement others and these will make your images more successful.

The effect of a chosen color can range from evoking basic emotions to stimulating thought. For example, mixing red, white, and blue in a piece—even when not in the shape of a flag—subtly suggests British, American, or French nationality.

The colors in your piece can also speak volumes about the mood of the character captured within. Here are just a few examples of how colors can directly reflect or provoke a mood: Red, orange, and yellow are warm colors. They tend to suggest warmth, passion, or even danger. Our mind associates them instantly with fire or the sun. The color red, however, can suggest far more. It is the color of warning signs and is often used for neon lighting in certain morally dubious areas of town.

Blue, green, and purple are the cool colors. They can be soothing because of what they represent; green makes us think of nature, blue can denote the sky or the sea. However, blue can also show coldness, loneliness, and depression. It can sum up many negative emotions. Purple tends to represent something with more of an "edge" and is a relatively eccentric color. It can also be a symbol of wealth or nobility. Finally, the neutral colors (gray, beige, and brown) can create a subtle and toned-down image. However, they are sometimes more effective when used to contrast the more vibrant colors in an image.

DESIGN

How you choose to combine colors is one of the main factors in giving your work a unique style.

Sometimes you may simply want your character to wear a realistic, modern outfit. In that case, you are unlikely to want to use any color scheme that is too garish or clashing. Other times (and more frequently in manga) you may want to try something radical!

Don't feel that you should even be limited to conventional coloring styles. Try coloring an entire image in varying shades of just one color and see what kind of effects you can create.

THE THREE GOLDEN RULES OF COLORING

Research

If you are attempting to create a realistic piece, be sure that your colors suit the genre or timescale of your image. If your piece is a historical one, you will need to consider the common color schemes of the era.

Design

When coloring an outfit, try to make sure that a design element is present. For example, if a character wears a red scarf, perhaps they would have matching red shoes or ribbons on their socks? A little consistency, even in the craziest color scheme, can add professionalism to an image.

Have Fun!

What you see here are the theories and starting points. It's up to you to experiment and capture your own style. Remember that coloring can be a long process, but very rewarding in the end.

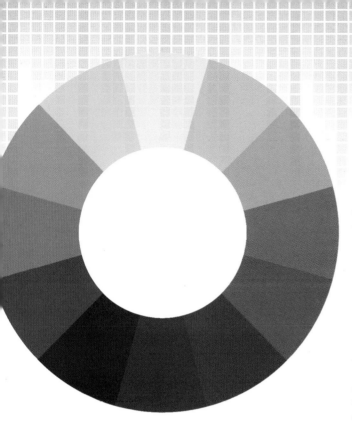

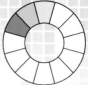

If you want colors that relate closely to each other, choose analogous colors—colors that are close together on the color wheel. By choosing several analogous shades, you can achieve a more subtle color scheme.

For something a little more daring, try complementary colors. By choosing two colors that are directly opposite each other on the color wheel, you can achieve some incredible contrast and vibrancy. However, be wary of making your scheme too garish when trying out this style.

Primary

Most people think of the primary colors as red, blue, and yellow. More accurately, they are cyan, magenta, and yellow. These colors can be combined to create any single color of the spectrum.

Secondary

Fewer people may be aware of the secondary colors: orange, purple, and green. Each can be made by mixing two of the primary colors together.

Tertiary

Finally, we move on to the tertiary colors: yellow-orange, red-orange, red-purple, blue-purple, blue-green, and yellow-green. These colors can be created using one primary and one secondary color.

By putting all of these colors into a color wheel, we are given a simple overview of color and can quickly see which colors should be used in conjunction with others.

Lastly, there is the the triadic color scheme. As the name suggests, the idea here is to choose three colors which are evenly spaced on the wheel. One way to use this is to choose two colors to form the basic color scheme, and add a third as an occasional highlight for accent and depth. This works well because that third color will be equally different to each of the base colors.

CEL SHADING

Cel shading refers to the style of using flat block colors to represent areas of light and shadow on a picture. This relates to the use of animation cels in Japanese anime, and the way that colors are used to define depth. The use of darker and lighter tones to define shape and shadow was so unique and distinctive that it became intrinsically associated with Japanese animation. Although some Western studios have adopted the technique since, it is still something that helps to make authentic-looking and aesthetically pleasing anime-style characters.

The appearance of cel-style shading is very easy to emulate using Photoshop. By making the most of layers, it is possible to achieve a high-quality look very quickly. The time can be spent focusing on the details rather than getting the overall cel look to work effectively.

Finally, cel shading is often the basis for many other visual styles, such as airbrush or natural media, and acts as the basis of lighting for most images. Time spent on the cel-shading process will improve the look of any image, regardless of the look you require for the final piece.

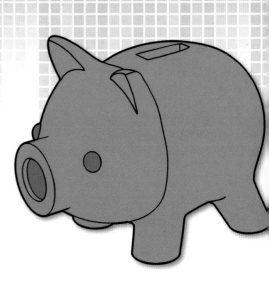

ORIGINAL
This pig has no shading, just simple base colors. The most important aspect of cel shading is understanding how light falls, and how the shape of an object will affect the shading.

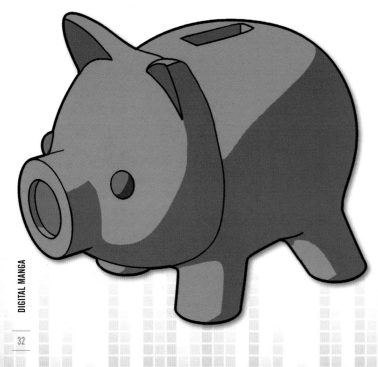

SHADING
The lightest parts of an object are those that face the light source, and the darkest parts are those that face away from the light. Unless the light source is very small and weak (such as the glow from a TV screen or a flickering flame) the light will affect the object equally. In other words, about the same amount of light falls on all the areas that point toward the light.

The light source on this pig is originating from the top left, so any areas facing away from there have been shaded more darkly.

SHADOWS

Effective definition of shadows can make all the difference to how "solid" your picture looks. When the objects in the scene are obviously affecting one another, your picture becomes much more believable. Firstly, the pig now casts a shadow onto the floor. The shape of his body has been defined, and the ears can be seen in the shadow too. Secondly, the pig is also casting shadows on himself. You can see how the snout is blocking the light from his face and the two legs nearest us are not directly lit at all. It's easy for objects to cast shadows on themselves, so you need to be aware of this.

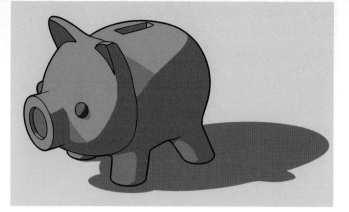

DARK SHADOWS

With shiny materials such as plastic or skin (in some instances), you may wish to further define the shadows. Giving these areas a heavier shadow can help to define the shape of the object more vividly.

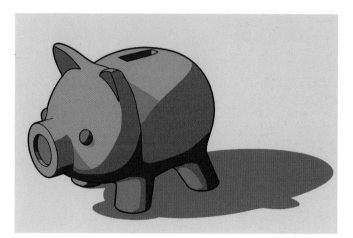

HIGHLIGHTS

Highlights are only necessary on shiny materials, and can be used to a greater or lesser degree depending on the effect that is desired. In this image, highlights have been added from the main light source. However, some additional highlights have been added in the opposite direction, implying some sort of other light source nearby. This style of "backlight" is a popular method to give an object more volume.

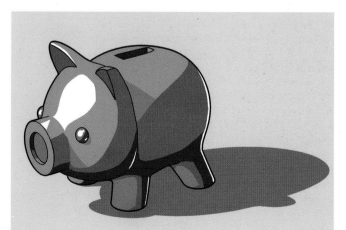

APPLYING BASIC CEL SHADING

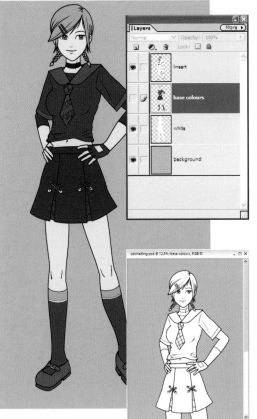

3 Choose a medium-range color, such as a mid blue or a dull pink. This will be used for your shadows. Gray is an alternative too, but will generally come out more drab than a tinted shade. In any case, you can change this color easily later, so don't worry too much about it at this stage. Now select the Brush tool and choose a hard-edged brush. Begin applying your color roughly over the image in the areas away from the light source—this is where a graphics tablet (see page 13) is useful.

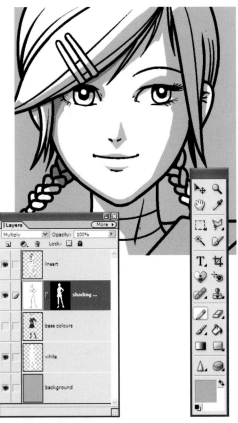

1 Prepare your image by making sure it has the base colors applied, as described in the Blocking In Colors section (see page 26).

2 Create a new layer on top of the other layers, and set its blending mode to Multiply. This will be used for the shading and shadow definition. Now hide the base color layer of the image, so the line-art is visible against a white background.

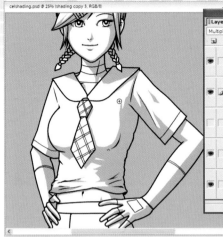
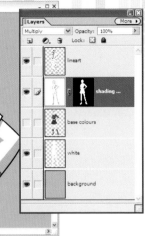

4 Using either the Eraser tool or the Brush tool set to white, clean up the image and add definition to the shading. Remember to pay close attention to areas that cast shadow, such as the nose and eye sockets.

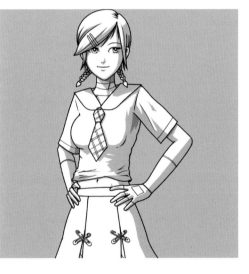

5 By choosing a darker shade of the same color, certain dark areas can be defined more heavily.

6 By revealing the color layer, you can now choose how to adjust your colors. You can easily work on shading with the colors turned on.

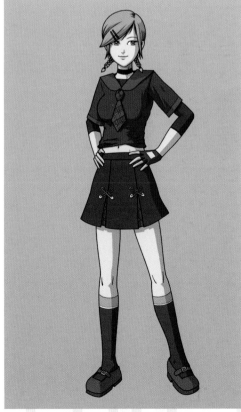

DIGITAL MANGA

HIGHLIGHTS AND DETAILS

Although a solid foundation of color is crucial for a high-quality picture, much of its overall appearance is derived from highlights and other important details which are added to the picture later. Attention to detail will make all the difference between a good picture and a great picture.

MATERIAL TYPES IN CEL SHADING STYLE

Different types of materials and surfaces will be shaded in different ways, either in the way they reflect light or how simple and "matte" the surface is in comparison. Although this can vary in some cases (for example, polished metal is more reflective than tarnished metal), here are some examples.

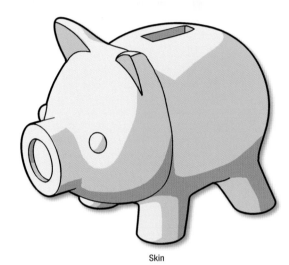

Skin

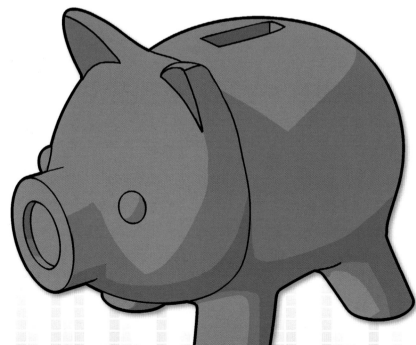

Rubber

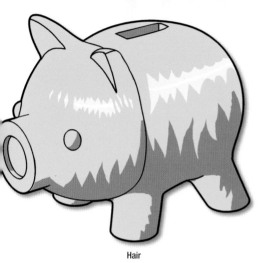

Hair

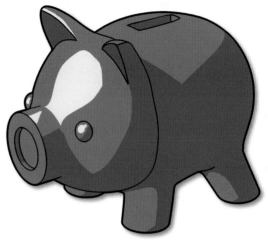

Plastic

Cloth

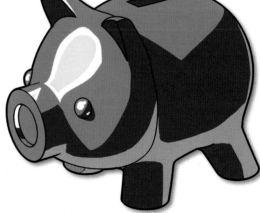

Metal

ADDING HIGHLIGHTS

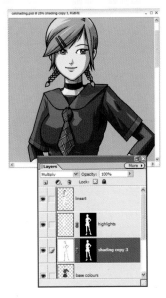

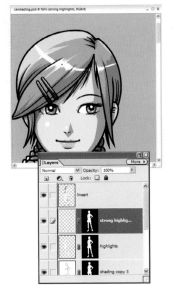

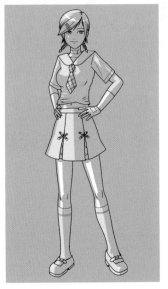

1 Create a new layer above the color layer. Label this as "highlights." Set the layer to Screen mode, so only that layer will lighten. Set the opacity to about 60%.

2 Using a white color, apply areas of light with consideration to the light source. Consider the type of material, and whether or not it would in fact have highlights, or would be better left without.

3 Create another layer, labeled "strong highlights." Leave this at 100% opacity.

4 We'll now add the brightest highlights to areas such as metal, hair, and shiny areas of skin. Keep your chosen color as white, and begin to add small dots, lines, and "glints" of white light to areas that would especially reflect light.

5 As with the shading, it is possible to turn off the color layer's visibility to check that your highlights are accurate and that no areas have been missed.

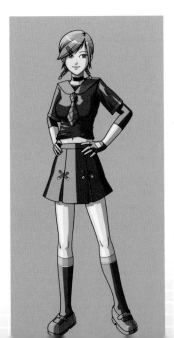

6 Finally, turn on all the layers to see the completed image.

FINE-TUNING YOUR COLORS

Although using layer modes such as Screen and Multiply is great for speeding up the process of shading and highlighting, sometimes the results aren't entirely satisfactory. Luckily, you can fine-tune your colors afterward.

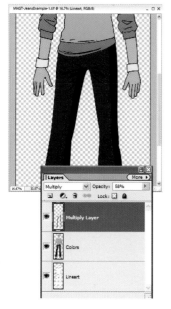

Select the shading layer

Choose the Paint Bucket tool and turn on Contiguous and All Layers, with the Tolerance set very low. Choose a color to contrast with the area and fill in the area. You can repeat this until you find a color that creates the right effect. Selecting the section with the Magic Wand and then altering it with the Adjust Hue slider can also be a great way to achieve this effect.

Change the shade of your multiply area to contrast with the color beneath

Although a blue Multiply layer (the shadows layer) will look very striking against purple, sometimes it just won't have the same impact against similarly toned areas (such as blue shading on blue jeans).

TIP

Using Additional Layers
If you use separate layers for each level of highlight, you can easily fine-tune the results by using the Opacity setting.

Highlights for eyes

The representation of eyes in manga is possibly the most striking aspect of the genre. Typically renowned for its glossy, saucer-sized characters, even manga styles with smaller eyes devote a lot of attention to this area. Highlights and detail on the eyes can make all the difference to any manga-style picture. Even a flat-colored picture can be improved hugely with some extra detail in the eyes.

- The center of the eye should be a darker color than the rest of the eye, giving a sense of depth.

- Highlights should be drawn at both the top and the bottom of the eye, just as you would with a glass or metallic object.

- You may wish to create a layer above the line-art, and draw your highlights over this. Failing that, you can just delete parts of your line-art if you think the definition is too heavy.

AIRBRUSH TECHNIQUE

Before computers were used to produce artwork, people often used airbrushes to create gradients and soft transitions between different colors. Rather than just using solid tones, lighting can be represented as a smooth blend between light and dark.

Thankfully, this method of painting is very easy in Adobe Photoshop, Photoshop Elements, and other digital painting software. By using "soft brushes" (with or without the dedicated Airbrush setting) it's possible to emulate this look accurately, yet still allow for the artwork to be adjusted.

SOFT BRUSHES

For an airbrush technique the use of soft brushes is crucial. These are represented as circles that become lighter toward the edge. The larger the brush, the softer the gradient will be. Therefore changing the size of the brush using the [and] keys can have an apparent effect on the presently selected brush's softness, though holding Shift and pressing [or] will affect it without changing the size of the brush (see page 18).

5	9	13
17	21	27
35	45	65
100	200	300

USE OF AIRBRUSH STYLE

An airbrush style is typically used to soften the highlights based upon the direction of the main light source. This is achieved by using a soft brush and going over the shaded edge. A larger gradient implies a more gently curved surface. To see this effect in the real world, just look how the light falls on a cylinder—say an aerosol can—as opposed to an angular item.

A popular technique is to use "rear lighting" when using airbrush methods combined with cel-style coloring. This retains the hard edge of the cel shading, but benefits from some of the softening of the airbrush, as though to imply ambient light. Using very subtle shading to simulate a rear light can be very effective in introducing curve and volume to an image without losing the charm of the cel-shading style.

By combining these two looks, an interesting use of shade can be captured, especially as the front light is much more obvious than the rear light. Even choosing to leave hard shaded edges, such as the shadow cast by the pig's nose, will give a wonderful sense of volume to the shading.

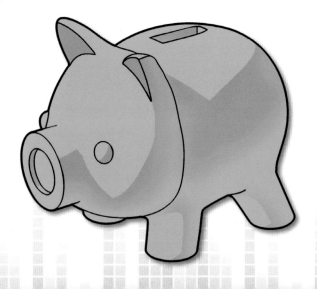

USING CEL SHADING AS A BASIS

As airbrush technique follows the same fundamental rules as cel shading, often it is best to start off with the same solid shading. For this image, a dull red shade is used with a Multiply layer, with a blue color to allow proper contrast against the red trousers.

Remember to pay attention to the direction of light, and define the volume of the character.

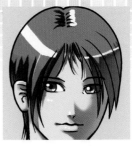

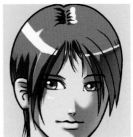

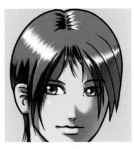

1 Begin by softening off the shading. To do this, it's often worth creating a duplicate of your shading layer, and hiding it. This creates a backup of the color work, just in case you make any large errors with this step.

2 Using a soft white brush, or the Eraser tool with a soft head, work over the existing shading layer to lighten the edges where light falls. Hard or shiny materials will have heavy contrast, whereas soft materials such as skin will often have very soft shadows, unless they are wet.

3 Adjust the opacity of your brush with the opacity slider, or by using the number keys at the top of the keyboard. This will allow you to control how subtle your brushstrokes will be.

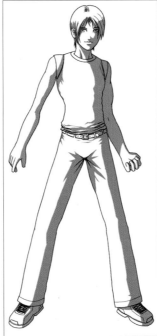

4 Shiny highlights with airbrush pictures are done in a very similar way to the highlights on a regular cel-shaded picture. By combining the methods of highlights from cel style with some of the airbrushing, you can end up with something that appears even more striking. First draw a solid block of highlight, without the definition of fabric or hair.

5 Use the Smudge tool to create a point in the highlight area.

6 Move the cursor backward and forward to represent the shape of the hair.

USING THE BLUR FILTER TO SOFTEN SHADING

The filters in Photoshop are very powerful tools, but overuse can often lead to an image being ruined. However, when used with subtlety and careful application, they can add greatly to the atmosphere of an image.

3 Using the Gaussian Blur filter, adjust the layer until it spreads out significantly. The amount you need to blur this highlight will depend on the look you want. Here, for example, a radius of 75.4 is ideal for the soft light effects.

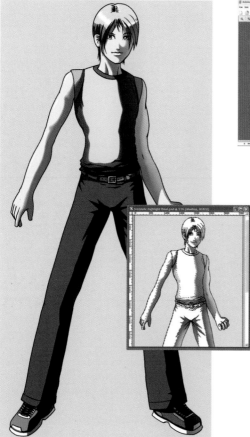

1 Choose the shading layer, use the Magic Wand selection tool and select all the white areas of the image. This will roughly select all the parts of the image that haven't got shadowing applied to them.

2 Create a new layer, with the layer style set to Overlay. Fill in the area with a color such as yellow, pink, or white (make sure that All Layers and Contiguous are unchecked).

4 Select the background area and trim this layer to fit (or use a mask), and change the opacity until you're happy with the effect. It's also possible to create interesting soft shadow results by duplicating the shading layer and blurring it. You will have to experiment with the opacity of the blurred and unblurred shading layer until you get the right look, but it can appear quite soft and interesting.

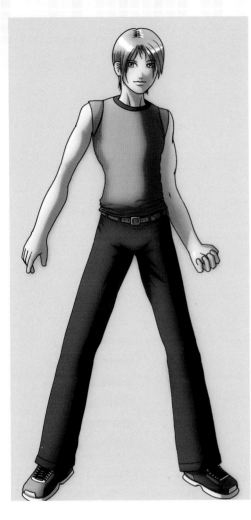

Using these airbrush techniques, you can end up with a cool and stylish image.

DIFFERENT LOOKS

With Photoshop it is very simple to quickly see different looks for your artwork. Remember that there's no correct way for your artwork to look, and try to experiment as much as possible to find the style that suits you most. (You can always go back to the previous state by pressing Ctrl/Cmd + Z or by using the History palette.) By adjusting the opacity of different layers you can completely change the way that shading,

highlights, and colors will affect the overall image. This version of the character was created by changing the shading layer to blue, with two blurred versions on top that were left as red.

NATURAL MEDIA

Simulated natural-media coloring is popular with manga artists in both Japan and the West. Computer-generated (CG) images are generally recognized as being pixel-perfect, but natural media is a move away from that perfection, emulating the textures and flaws of real paintings. As computers have become more powerful, it has become easier and more desirable to recreate complex, realistic-looking techniques that still have all the benefits and the malleability of CG artwork. There are several programs available specifically for natural media simulation, most notably Corel's Painter, but you can also create similar effects in Photoshop or Photoshop Elements.

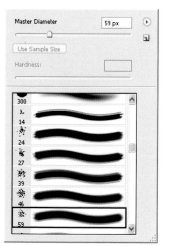

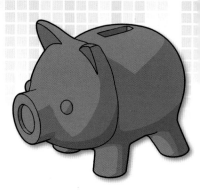

1 Start by coloring your base colors using the method on page 26. Make two new layers, one called "palette" and one called "shading." You can use as many or as few layers for shading as you like—here, careful use of selection tools means we'll only use one.

2a First, use the Magic Wand tool to select all the areas of the color you want to shade first. Make sure Contiguous is unchecked and All Layers is checked in the Tool Options bar, then click somewhere on your target color. All pixels of that color will be selected.

2b Select the Pencil tool from the Toolbox, then choose a natural-looking brush from the drop-down palette in the Tool Options bar. This is the media you'll use to color the image. When coloring in natural-media style, it is best to start with the darkest shadows first, then blend them out with increasingly lighter colors. Since hair has a great range from dark to light, we'll start with that. Set the brush to 15% opacity, and build up the color with many small, quick strokes. This will create more texture than longer strokes.

3 To make the image look more natural and to add more variation to the shading, colored tints can be lightly added as the image is shaded. In this picture, a reddish shade is added to enrich the color.

4 Next, a lighter color is applied to blend the shading gradually.

5 The base color is used to blend the shading completely.

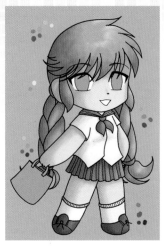

7 Once you have finished coloring the hair, turn to the skin and clothing. Typically these are much less reflective than hair, so you only need to use minimal highlights.

6 Now add some highlights. As with the rest of the coloring, you should still work from dark to light, so blend the highlights toward the lighter shades as you go along. For shiny areas like hair and eyes, make the highlights brighter for more contrast. When the hair is finished, press Ctrl/Cmd + D to deselect the area, and move on to coloring the rest of the image.

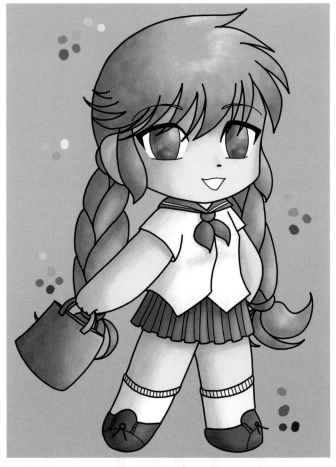

8 Color the small details last, such as accessories and eyes, as you can more accurately work out the lighting and shading to coordinate them with the rest of the picture. The eyes are very brightly lit, with highlights reflecting off even the shadowed side. Even though the image looks complete, there are a couple of extra touches you can add to give it a little extra polish.

9 Finally, create a new layer and call it "details." Set its blending mode to Multiply so anything you paint onto the layer will overlay lighter shades underneath. Using a very light, bright pink color, shade the cheeks, elbows, and knees to give them a rosy glow. For the white dots, create another new layer—call it "speculars"—and add soft, white dots on the side where your light source is. The speculars need to be on a new layer, as you cannot paint white on to multiply layers; white is effectively transparent with the Multiply setting since the stronger color always takes precedence. Now the image is complete.

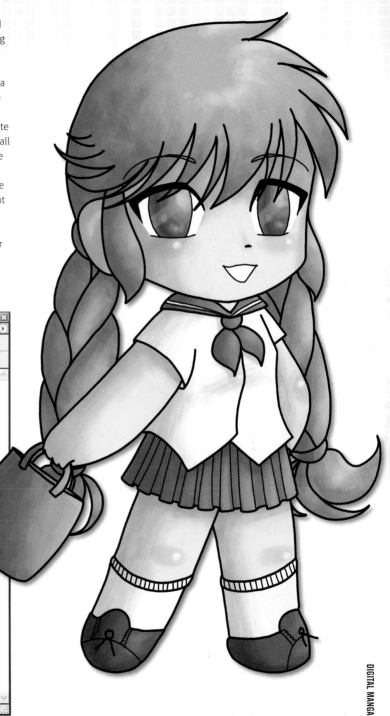

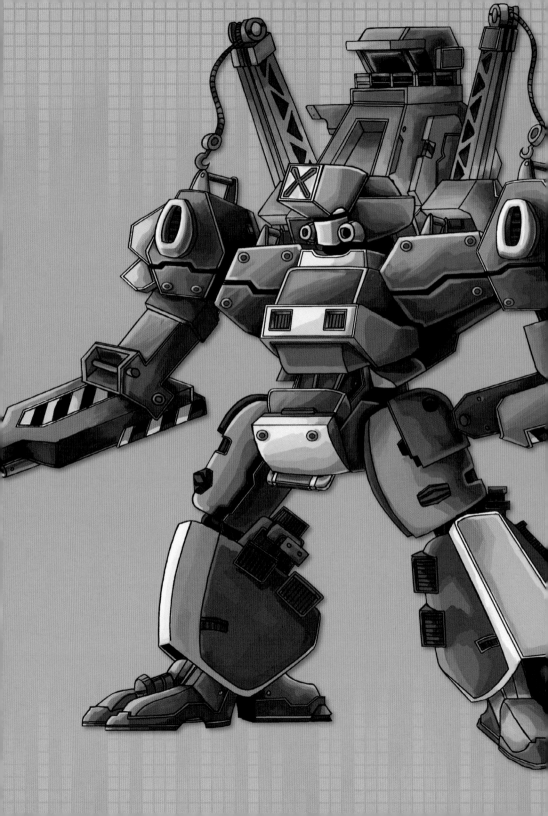

CHARACTERS

CONTEMPORARY MALE

This, together with the Contemporary Female, is one of the most richly varied characters on the disc. There are 1,260 possible combinations of heads, torsos, and legs, though this is dramatically increased by mixing and matching with the Sci-fi Male character (see page 62). You'll also want to explore "flipping" components horizontally. This is especially useful in getting the stance right.

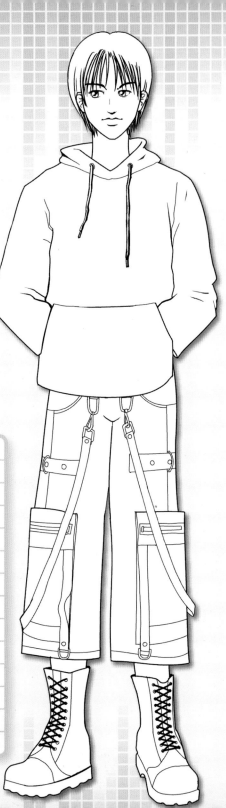

❯ **Hoodie**
Head 4
Torso 4
Legs E

LAYERS

	Head 15
	Head 14
	Head 13
	Head 12
	Head 11
	Head 10
	Head 09
	Head 08
	Head 07
	Head 06
	Head 05
	Head 04
	Head 03
	Head 02
	Head 01
	Guitar Hand
	Guitar Small
	Guitar Large
	Torso Guitar 2
	Torso Guitar 1
	Torso 8

	Torso 7
	Torso 6
	Torso 5
	Torso 4
	Torso 3
	Torso 2
	Torso 1
	Legs G
	Legs F
	Legs E
	Legs D
	Legs C
	Legs B
	Legs A

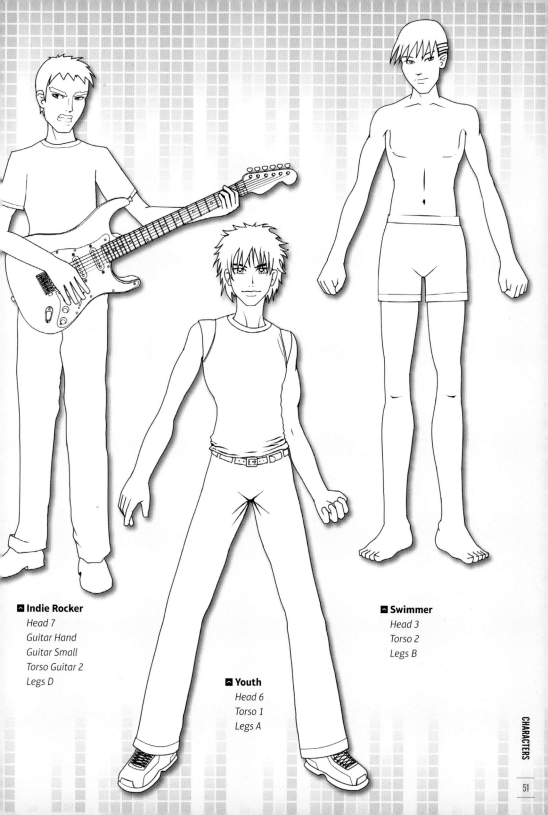

◤ Indie Rocker
Head 7
Guitar Hand
Guitar Small
Torso Guitar 2
Legs D

◥ Youth
Head 6
Torso 1
Legs A

◤ Swimmer
Head 3
Torso 2
Legs B

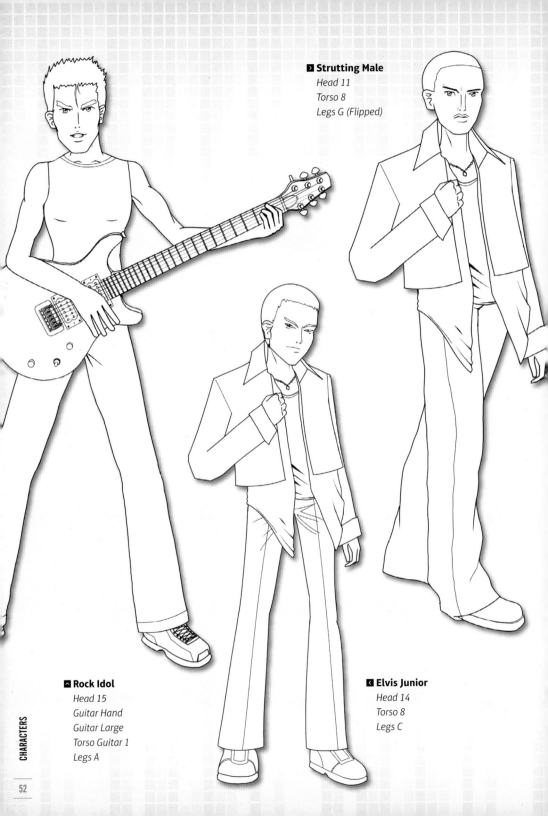

▷ Strutting Male
Head 11
Torso 8
Legs G (Flipped)

⌃ Rock Idol
Head 15
Guitar Hand
Guitar Large
Torso Guitar 1
Legs A

◁ Elvis Junior
Head 14
Torso 8
Legs C

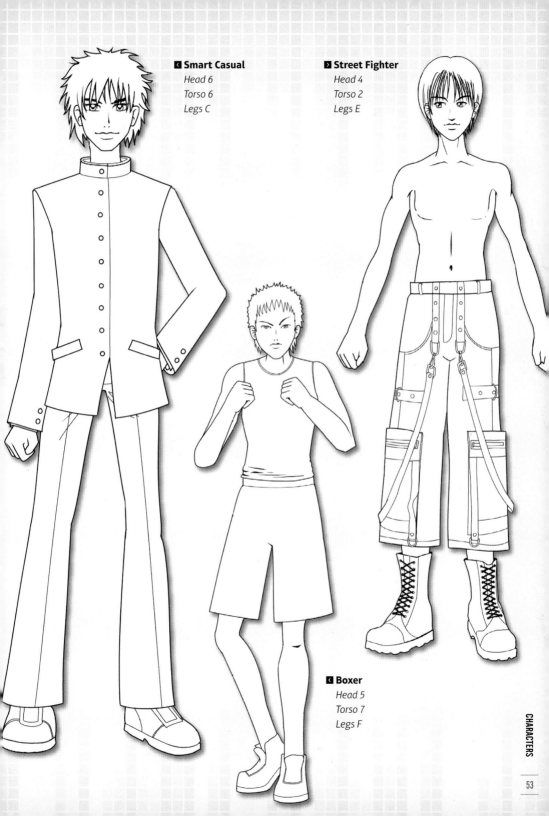

◄ **Smart Casual**
Head 6
Torso 6
Legs C

► **Street Fighter**
Head 4
Torso 2
Legs E

◄ **Boxer**
Head 5
Torso 7
Legs F

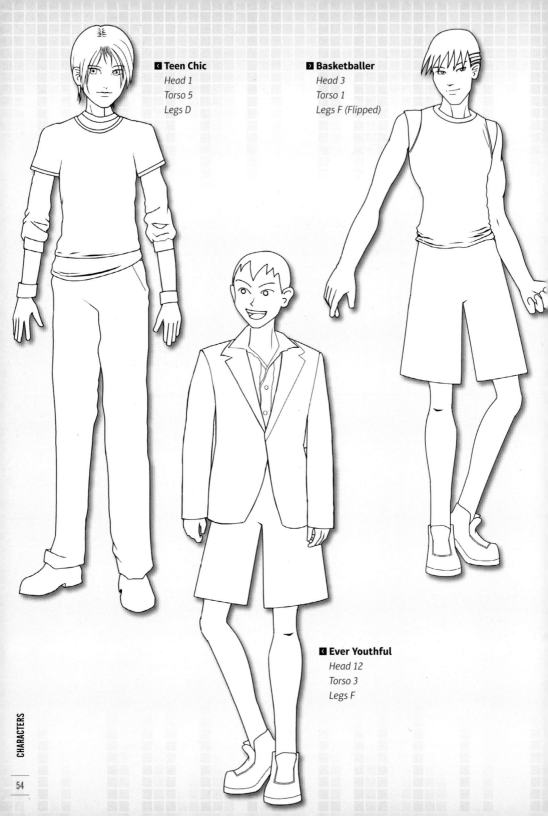

◀ **Teen Chic**
Head 1
Torso 5
Legs D

▶ **Basketballer**
Head 3
Torso 1
Legs F (Flipped)

◀ **Ever Youthful**
Head 12
Torso 3
Legs F

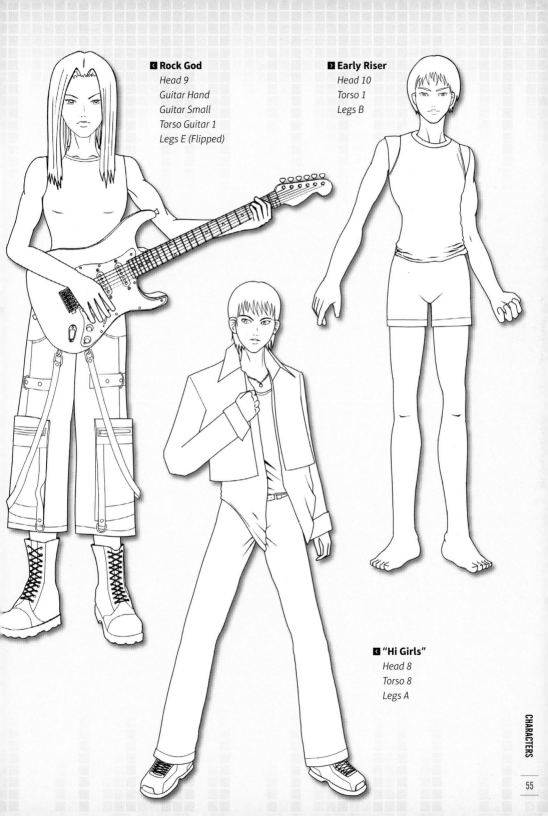

◀ **Rock God**
Head 9
Guitar Hand
Guitar Small
Torso Guitar 1
Legs E (Flipped)

▶ **Early Riser**
Head 10
Torso 1
Legs B

◀ **"Hi Girls"**
Head 8
Torso 8
Legs A

CONTEMPORARY FEMALE

As with the Contemporary Male, this character can be assembled from her own components, or in combination with the Sci-fi Female character. Because of the variety of poses, you might find the Move tool invaluable, and there is an additional file filled with accessories. Women's hair is sometimes more complicated than men's, so there are layers beneath the torso to create long hair effects, different styles with the heads, and some extra styles you might want to add over the head layer, such as hair curls. Excluding the Sci-fi variations, all this adds up to over 1.4 million combinations.

LAYERS

Hair Buns	
Hair 07	
Hair 06	
Hair 05	
Hair 04	
Hair 03	
Hair 02	
Hair 01	
Hair Curls	
Head 12	
Head 11	
Head 10	
Head 09	
Head 08	
Head 07	
Head 06	
Head 05	
Head 04	
Head 03	
Head 02	
Head 01	

Guitar Hands	
Guitar Large	
Guitar Small	
Guitar Arms	
Arm 04 Right	
Arm 04 Left	
Arm 03 Right	
Arm 03 Left	
Arms 02	
Arms 01	
Dress 04 Arms	
Dress 04	
Shawl	
Scarf 02	
Scarf 03	
Scarf 01	
Dress 03	
Dress 02	
Dress 01	
Torso 08 (no Arms)	
Torso 07 (no Arms)	

Torso 06 (no Arms)	
Torso 05 (no Arms)	
Torso 04	
Torso 03	
Torso 02	
Torso 01	
Shorts	
Skirt 05	
Skirt 04	
Skirt 03	
Skirt 02	
Skirt 01	
Legs 07 Shoes	
Legs 07	
Legs 05	
Legs 04	
Legs 03	
Legs 02	
Legs 01	
Hair Ponytail 01	
Hair Ponytail 02	

Hair Bunches	
Hair Back 06	
Hair Back 05	
Hair Back 04	
Hair Back 03	
Hair Back 02	
Hair Back 01	

☑ Sexy Streetwear
Head 5
Torso 1
Legs 1
Skirt 2
Hair Ponytail 2

☑ Indie Chick
Head 4
Arms 1
Torso 5 (No Arms)
Legs 5

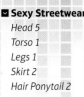

☑ Rock Princess
Head 8
Guitar Hands
Guitar Small
Guitar Arms
Torso 6 (No Arms)
Legs 1
Hair Back 5

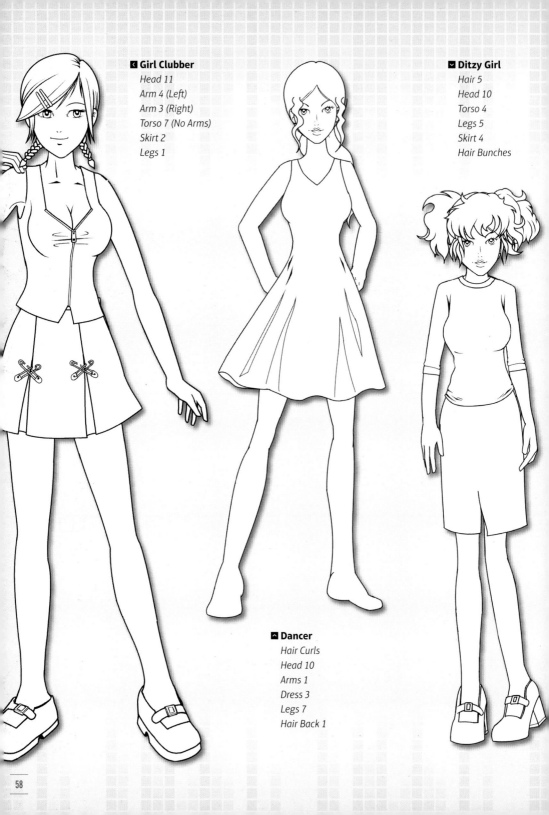

◄ Girl Clubber
Head 11
Arm 4 (Left)
Arm 3 (Right)
Torso 7 (No Arms)
Skirt 2
Legs 1

▼ Ditzy Girl
Hair 5
Head 10
Torso 4
Legs 5
Skirt 4
Hair Bunches

▲ Dancer
Hair Curls
Head 10
Arms 1
Dress 3
Legs 7
Hair Back 1

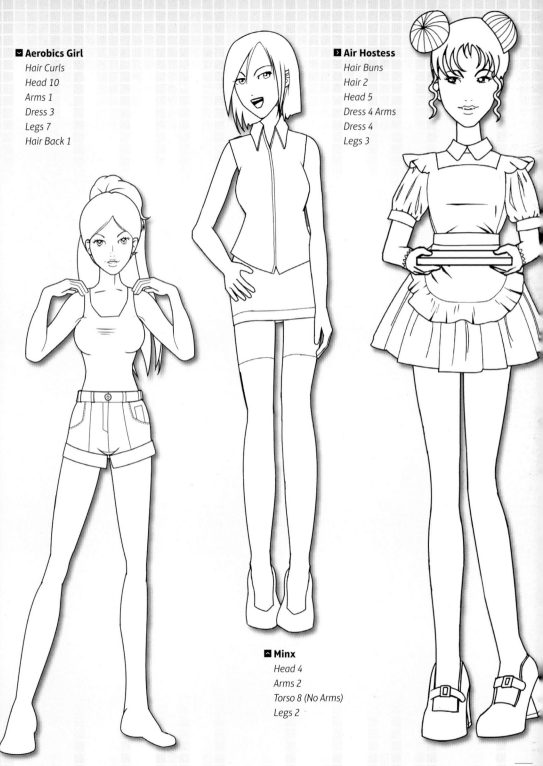

Aerobics Girl
Hair Curls
Head 10
Arms 1
Dress 3
Legs 7
Hair Back 1

Air Hostess
Hair Buns
Hair 2
Head 5
Dress 4 Arms
Dress 4
Legs 3

Minx
Head 4
Arms 2
Torso 8 (No Arms)
Legs 2

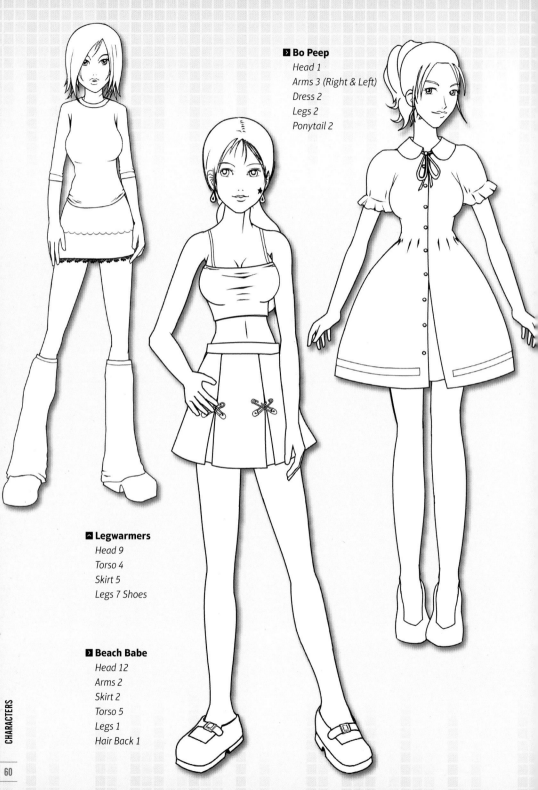

▶ Bo Peep
Head 1
Arms 3 (Right & Left)
Dress 2
Legs 2
Ponytail 2

⌃ Legwarmers
Head 9
Torso 4
Skirt 5
Legs 7 Shoes

▶ Beach Babe
Head 12
Arms 2
Skirt 2
Torso 5
Legs 1
Hair Back 1

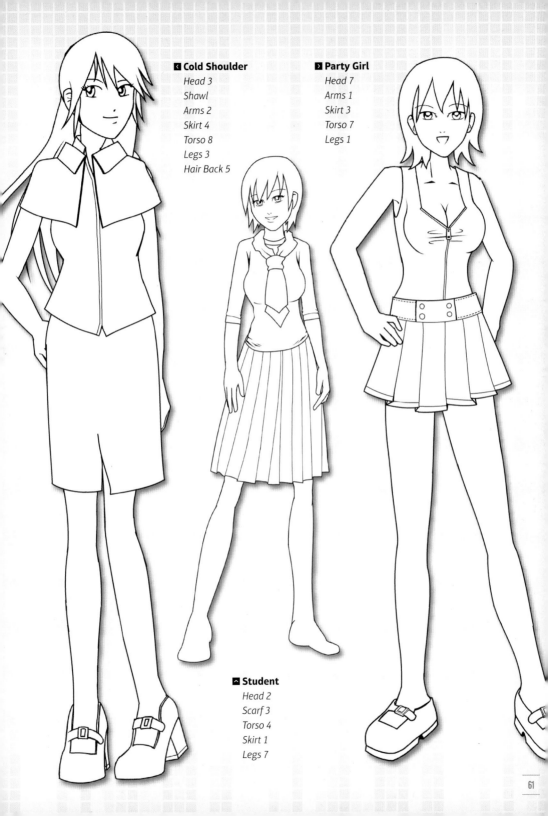

◄ Cold Shoulder

Head 3
Shawl
Arms 2
Skirt 4
Torso 8
Legs 3
Hair Back 5

► Party Girl

Head 7
Arms 1
Skirt 3
Torso 7
Legs 1

⌃ Student

Head 2
Scarf 3
Torso 4
Skirt 1
Legs 7

SCI-FI MALE

The Sci-fi Male comes with all the other layers we've already seen on the Contemporary Male, and more. This character has 320 pure Sci-fi variations, but combined with Contemporary Male, that comes to at least 3,795. And that's before you consider flipping or adding accessories.

LAYERS

Head Scifi 1	Head 14	Scifi Legs C	
Head Scifi 2	Head 15	Scifi Legs D	
Head Scifi 3	Accessory–Scifi Long Coat	Scifi Legs Straps	
Head Scifi 4	Torso Scifi 1	Legs 07	
Head Scifi 5	Torso Scifi 2	Legs 06	
Head Scifi 6	Torso Scifi 3	Legs 05	
Head Scifi 7	Guitar Hand	Legs 04	
Head Scifi 8	Guitar Small	Legs 03	
Head 1	Guitar Large	Legs 02	
Head 2	Torso Guitar 2	Legs 01	
Head 3	Torso Guitar 1		
Head 4	Torso 8		
Head 5	Torso 7		
Head 6	Torso 6		
Head 7	Torso 5		
Head 8	Torso 4		
Head 9	Torso 3		
Head 10	Torso 2		
Head 11	Torso 1		
Head 12	Scifi Legs A		
Head 13	Scifi Legs B		

Fist Fighter

Head Scifi 1
Torso 7
Legs 1

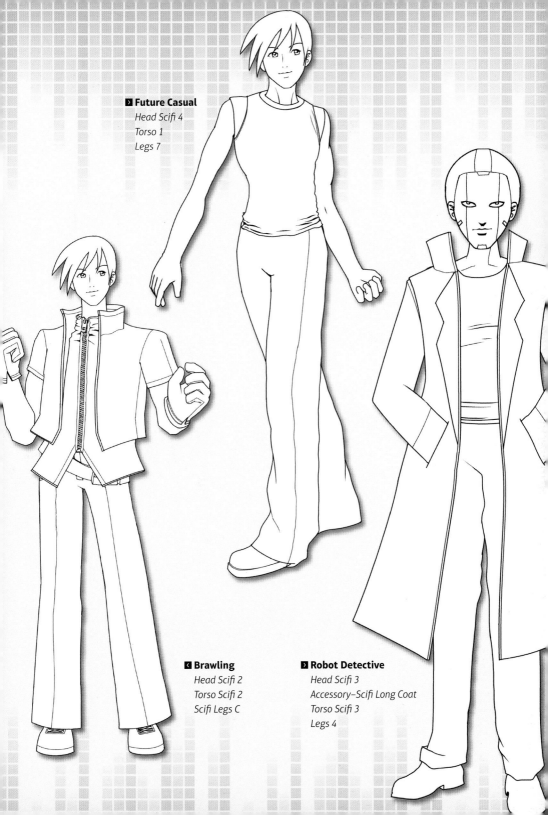

Future Casual
Head Scifi 4
Torso 1
Legs 7

◄ **Brawling**
Head Scifi 2
Torso Scifi 2
Scifi Legs C

► **Robot Detective**
Head Scifi 3
Accessory–Scifi Long Coat
Torso Scifi 3
Legs 4

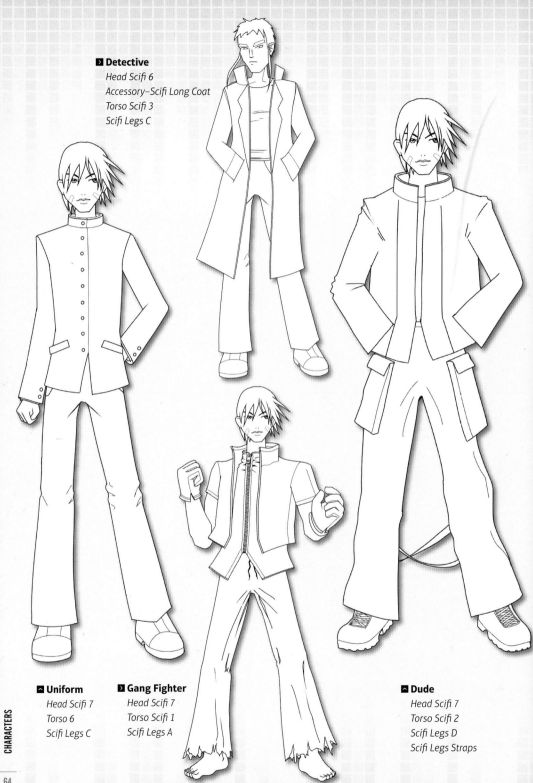

> **Detective**
Head Scifi 6
Accessory–Scifi Long Coat
Torso Scifi 3
Scifi Legs C

⌃ **Uniform**
Head Scifi 7
Torso 6
Scifi Legs C

> **Gang Fighter**
Head Scifi 7
Torso Scifi 1
Scifi Legs A

⌃ **Dude**
Head Scifi 7
Torso Scifi 2
Scifi Legs D
Scifi Legs Straps

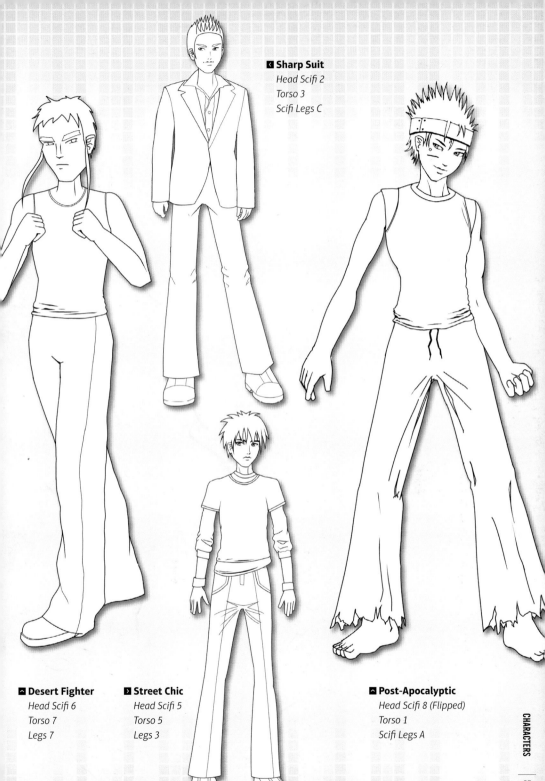

◄ Sharp Suit
Head Scifi 2
Torso 3
Scifi Legs C

⌃ Desert Fighter
Head Scifi 6
Torso 7
Legs 7

▶ Street Chic
Head Scifi 5
Torso 5
Legs 3

⌃ Post-Apocalyptic
Head Scifi 8 (Flipped)
Torso 1
Scifi Legs A

SCI-FI FEMALE

Combined with Contemporary Female, there is a phenomenal range of possibilities with this character— once again, there are well over a million permutations.

LAYERS

	Hair Buns
	Hair 07
	Hair 06
	Hair 05
	Hair 04
	Hair 03
	Hair 02
	Hair 01
	Hair Curls
	Scifi Head 01
	Scifi Head 02
	Scifi Head 03
	Scifi Head 04
	Head 12
	Head 11
	Head 10
	Head 09
	Head 08
	Head 07
	Head 06
	Head 05
	Head 04
	Head 03

	Head 02
	Head 01
	Guitar Hands
	Guitar Large
	Guitar Small
	Guitar (Arms)
	Arm 04 (Right)
	Arm 04 (Left)
	Arm 03 (Right)
	Arm 03 (Left)
	Arms 02
	Arms 01
	Torso Scifi 04
	Torso Scifi 03
	Torso Scifi 02
	Torso Scifi 01
	Scifi Skirt 03
	Scifi Skirt 02
	Scifi Skirt 01
	Scifi Legs 04
	Scifi Legs 03
	Scifi Legs 02
	Scifi Legs 01
	Hair Ponytail 01

	Hair Ponytail 02
	Hair Bunches
	Hair Back 06
	Hair Back 05
	Hair Back 04
	Hair Back 03
	Hair Back 02
	Hair Back 01

> **Party Gal**
> *Scifi Head 1*
> *Arms 1*
> *Torso Scifi 1*
> *Soft Skirt 1*
> *Scifi Legs 1*

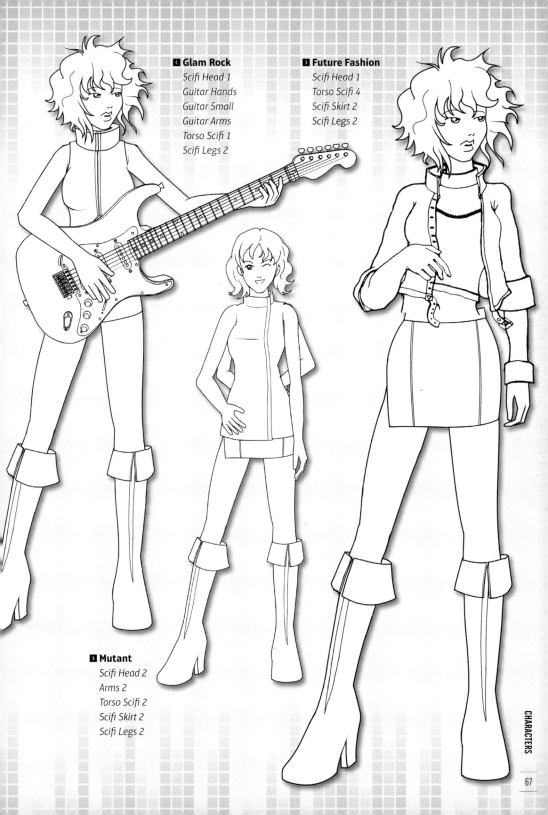

◄ **Glam Rock**
Scifi Head 1
Guitar Hands
Guitar Small
Guitar Arms
Torso Scifi 1
Scifi Legs 2

► **Future Fashion**
Scifi Head 1
Torso Scifi 4
Scifi Skirt 2
Scifi Legs 2

► **Mutant**
Scifi Head 2
Arms 2
Torso Scifi 2
Scifi Skirt 2
Scifi Legs 2

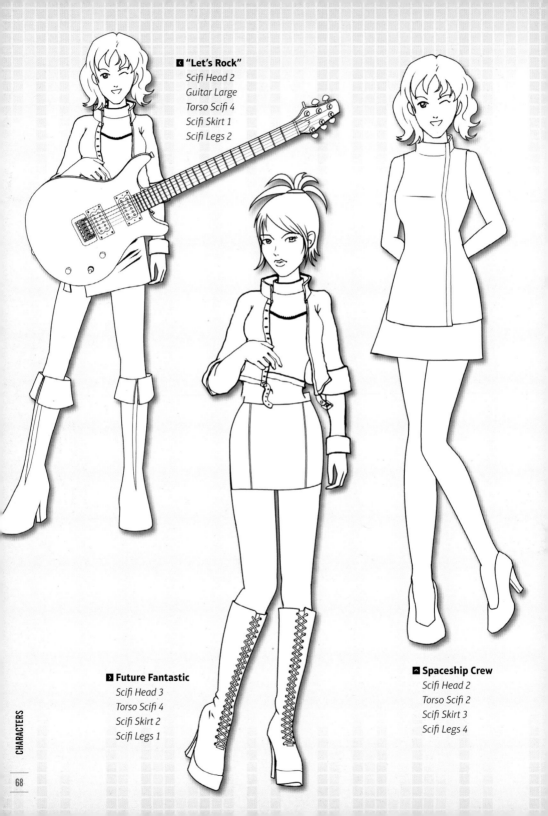

◄ "Let's Rock"
Scifi Head 2
Guitar Large
Torso Scifi 4
Scifi Skirt 1
Scifi Legs 2

► Future Fantastic
Scifi Head 3
Torso Scifi 4
Scifi Skirt 2
Scifi Legs 1

▲ Spaceship Crew
Scifi Head 2
Torso Scifi 2
Scifi Skirt 3
Scifi Legs 4

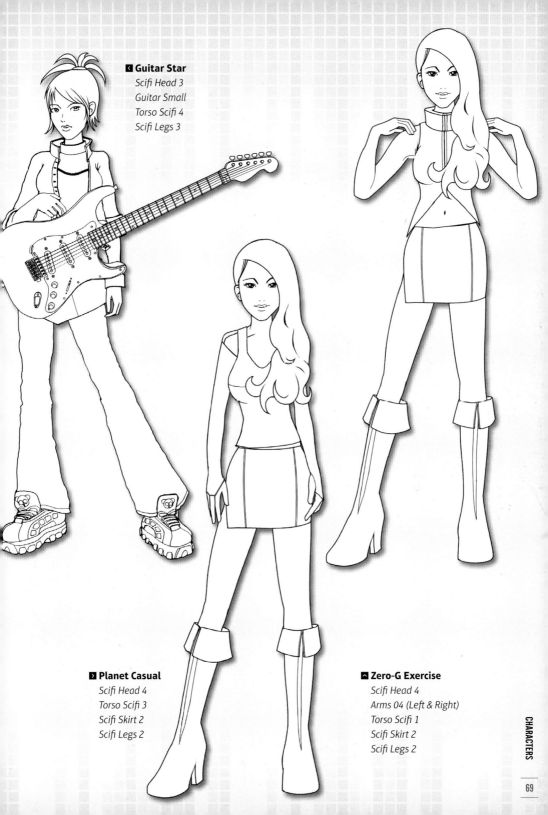

◄ Guitar Star
Scifi Head 3
Guitar Small
Torso Scifi 4
Scifi Legs 3

► Planet Casual
Scifi Head 4
Torso Scifi 3
Scifi Skirt 2
Scifi Legs 2

▲ Zero-G Exercise
Scifi Head 4
Arms 04 (Left & Right)
Torso Scifi 1
Scifi Skirt 2
Scifi Legs 2

TRADITIONAL ASIAN FEMALE

Traditional Asian dress can be created by combining leg and torso cover—whether it's traditional martial arts costumes or silk kimonos. Because of this, we've supplied a full set of heads from the Contemporary characters, as well as a variety of traditional costumes.

LAYERS

	Hair Buns
	Hair Curls
	Hair 07
	Hair 06
	Hair 05
	Hair 04
	Hair 03
	Hair 02
	Hair 01
	Head 12
	Head 11
	Head 10
	Head 09
	Head 08
	Head 07
	Head 06
	Head 05
	Head 04
	Head 03
	Head 02
	Head 01
	Kimono (Flipped)
	Kimono

	Cheongsam (Flipped)
	Cheonsam
	Hair Ponytail 01
	Hair Ponytail 02
	Hair Bunches
	Hair Back 06
	Hair Back 05
	Hair Back 04
	Hair Back 03
	Hair Back 02
	Hair Back 01

▶ **Traditional Chinese**
Head 5
Cheongsam
Hair Back 1

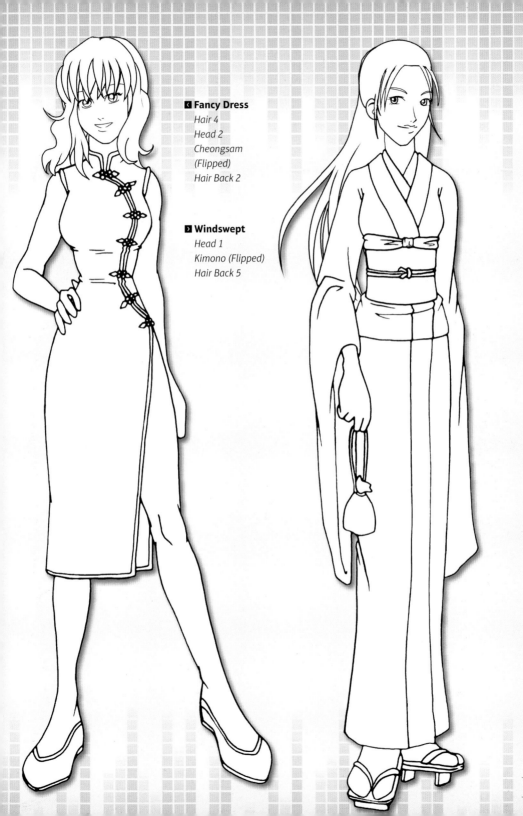

◄ Fancy Dress
Hair 4
Head 2
Cheongsam
(Flipped)
Hair Back 2

► Windswept
Head 1
Kimono (Flipped)
Hair Back 5

TRADITIONAL ASIAN MALE

The Traditional Asian Male haircut leaves us with fewer options than the Traditional Asian Female (including flipped dress, it's 60 versus 4,800), but there are more than enough expressions here to convey anger, aggression, or peace and clarity. If that's not enough, try combining elements from the Warrior section.

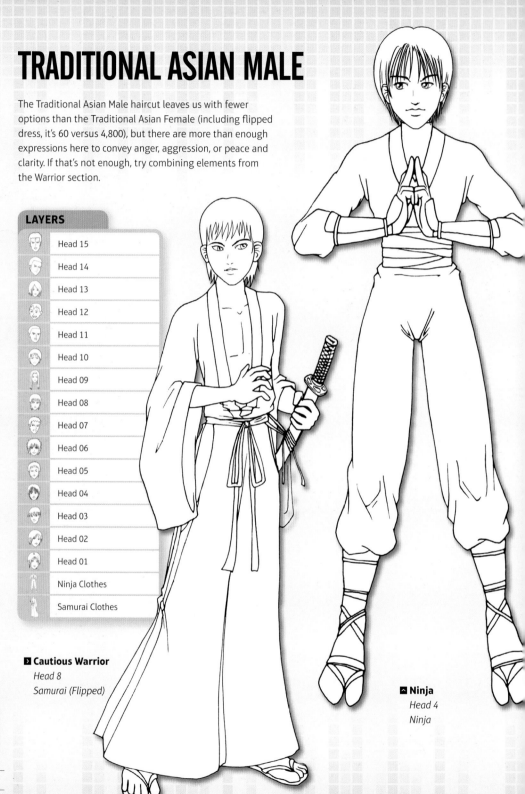

LAYERS

	Head 15
	Head 14
	Head 13
	Head 12
	Head 11
	Head 10
	Head 09
	Head 08
	Head 07
	Head 06
	Head 05
	Head 04
	Head 03
	Head 02
	Head 01
	Ninja Clothes
	Samurai Clothes

▸ **Cautious Warrior**
Head 8
Samurai (Flipped)

◤ **Ninja**
Head 4
Ninja

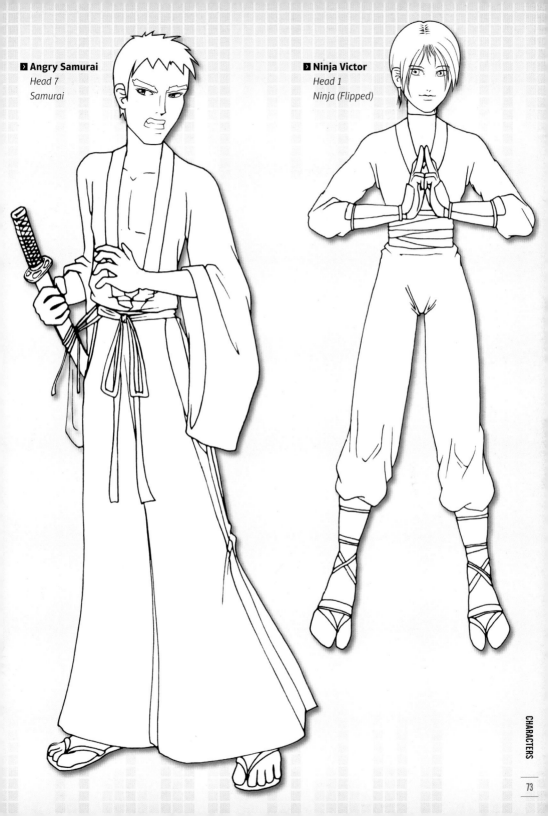

▶ Angry Samurai
Head 7
Samurai

▶ Ninja Victor
Head 1
Ninja (Flipped)

MALE WARRIOR

The Male Warrior character has a total of 35 layers and 125 possible poses. Simply select one set of legs (purple), one head (red), and one torso (blue) from the Layers palette. With each torso there are a choice of four accessories (yellow) but these will only fit together with the corresponding torso.

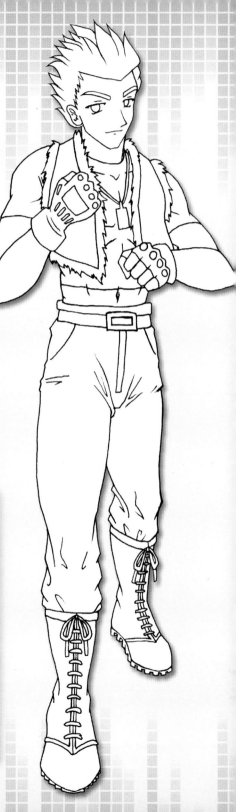

LAYERS

	Head A
	Head B
	Head C
	Head D
	Head E
	1–Tonfa
	1–Nunchucks
	1–Whip
	1–Twinblade
	1–Torso
	2–Bow
	2–Cutlass
	2–Wire
	2–Crossbow
	2–Torso
	3–Pipe
	3–Knife
	3–Knuckledusters
	3–Pistols
	3–Torso
	4–Sword Buckler
	4–Trident
	4–Kusarigama

	4–Battleaxe
	4–Torso
	5–Kung Fu Stance
	5–Tai Chi Sword
	5–Chinese Broadsword
	5–Curved Blades
	5–Torso
	Legs A
	Legs B
	Legs C
	Legs D
	Legs E

▶ **Knuckle Duster**

Head C
Knuckledusters
Torso 3
Legs C

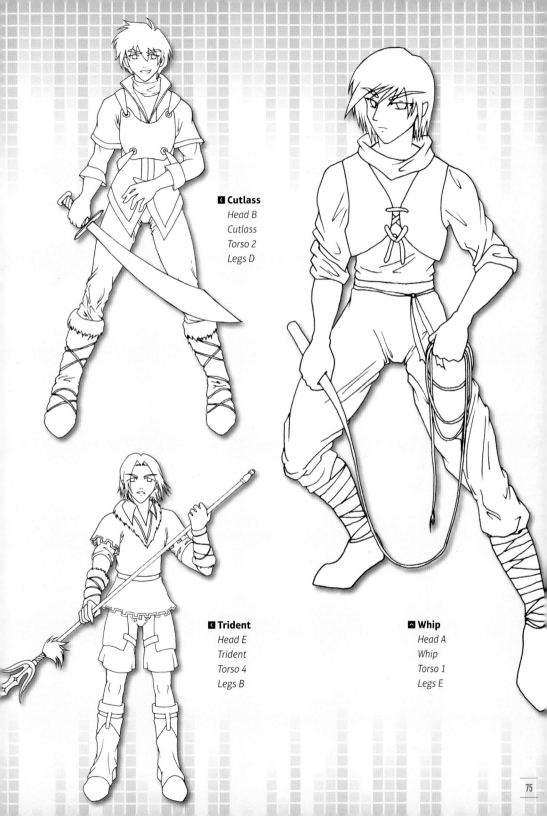

◄ **Cutlass**
Head B
Cutlass
Torso 2
Legs D

◄ **Trident**
Head E
Trident
Torso 4
Legs B

▲ **Whip**
Head A
Whip
Torso 1
Legs E

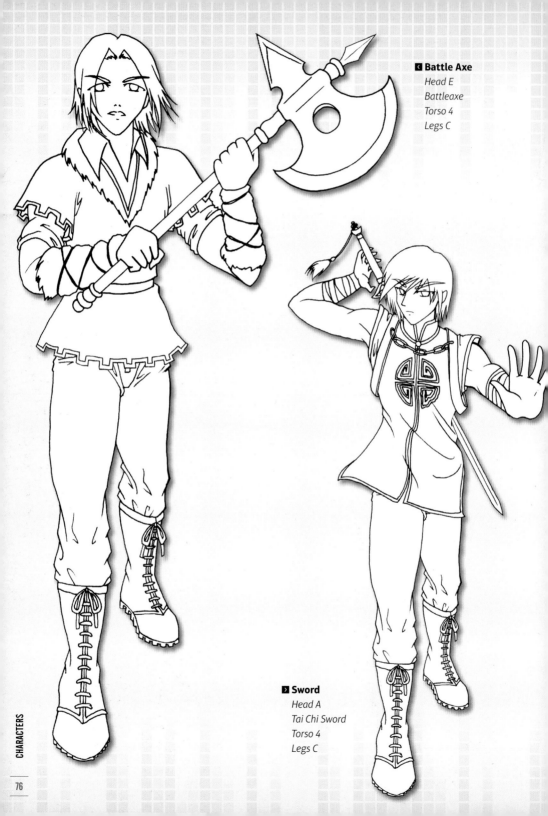

◄ **Battle Axe**

Head E
Battleaxe
Torso 4
Legs C

► **Sword**

Head A
Tai Chi Sword
Torso 4
Legs C

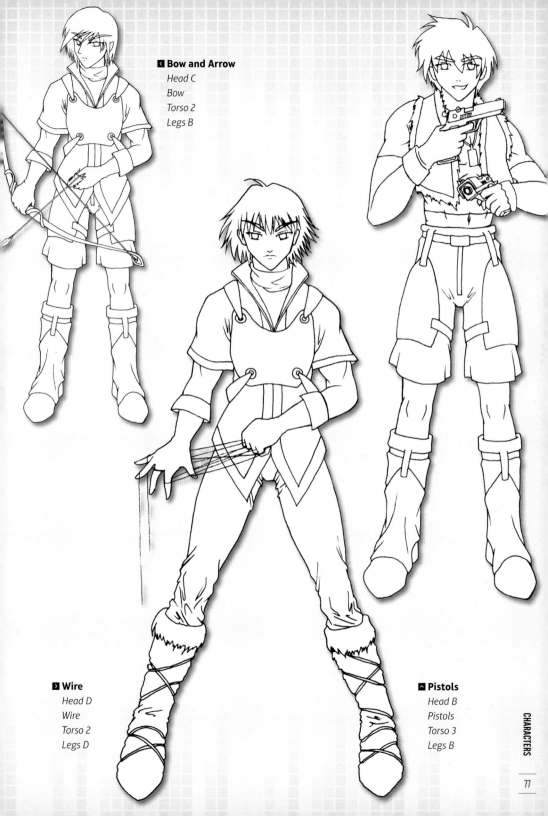

◄ Bow and Arrow
Head C
Bow
Torso 2
Legs B

► Wire
Head D
Wire
Torso 2
Legs D

▲ Pistols
Head B
Pistols
Torso 3
Legs B

FEMALE WARRIOR

The Female Warrior character has a total of 35 layers and 125 possible poses. Simply select one set of legs (purple), one head (red), and one torso (blue) from the Layers palette. With each torso there are a choice of four accessories (yellow), which fit together with the corresponding torso.

LAYERS

	Head A
	Head B
	Head C
	Head D
	Head E
	1–Shotgun
	1–Spear
	1–Katana
	1–Daggers
	1–Torso
	2–Whip
	2–Rapier
	2–Pistols
	2–Parry Knives
	2–Torso
	3–Kung Fu Hands
	3–Tonfa
	3–Halberd
	3–Fan
	3–Torso
	4–Mace Shield
	4–Curved Blades
	4–Chopper

	4–Bow
	4–Torso
	5–Throw Stars
	5–Machetes
	5–Kunai
	5–Bo
	5–Torso
	Legs A
	Legs B
	Legs C
	Legs D
	Legs E

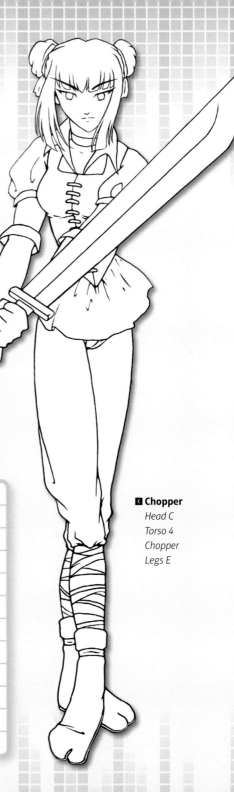

◄ **Chopper**
Head C
Torso 4
Chopper
Legs E

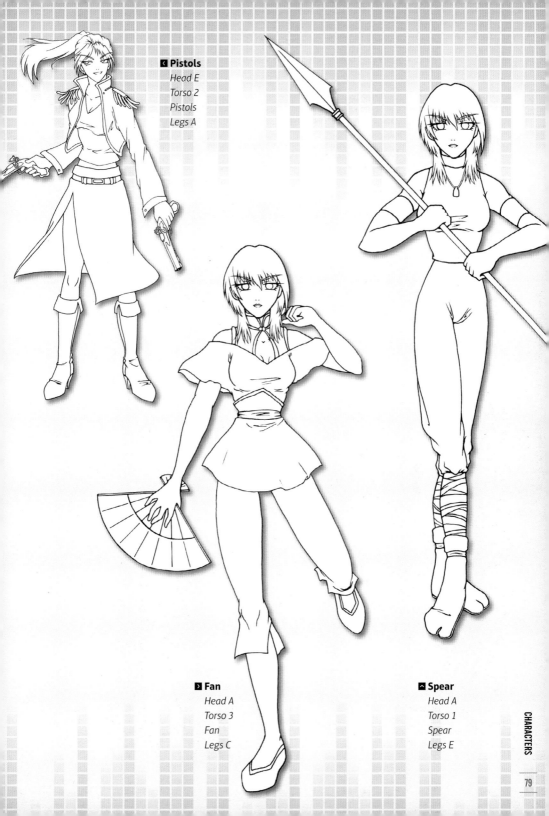

◄ Pistols
Head E
Torso 2
Pistols
Legs A

► Fan
Head A
Torso 3
Fan
Legs C

⬏ Spear
Head A
Torso 1
Spear
Legs E

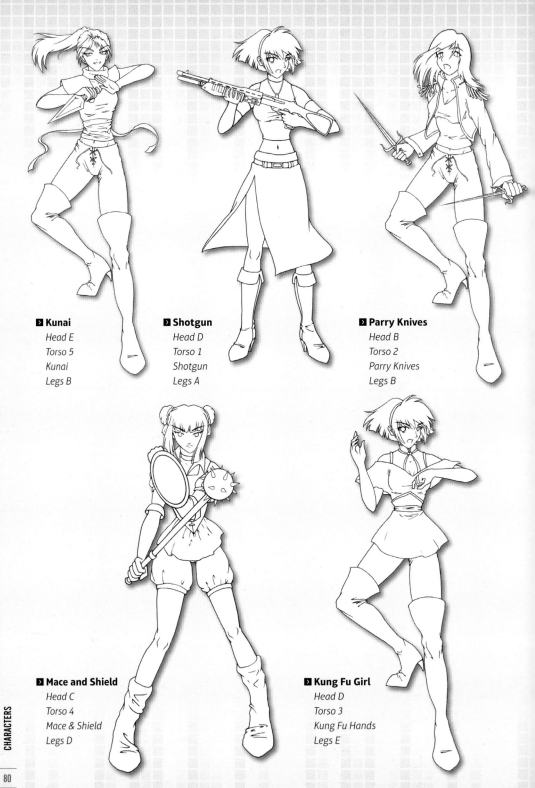

❯ Kunai

Head E
Torso 5
Kunai
Legs B

❯ Shotgun

Head D
Torso 1
Shotgun
Legs A

❯ Parry Knives

Head B
Torso 2
Parry Knives
Legs B

❯ Mace and Shield

Head C
Torso 4
Mace & Shield
Legs D

❯ Kung Fu Girl

Head D
Torso 3
Kung Fu Hands
Legs E

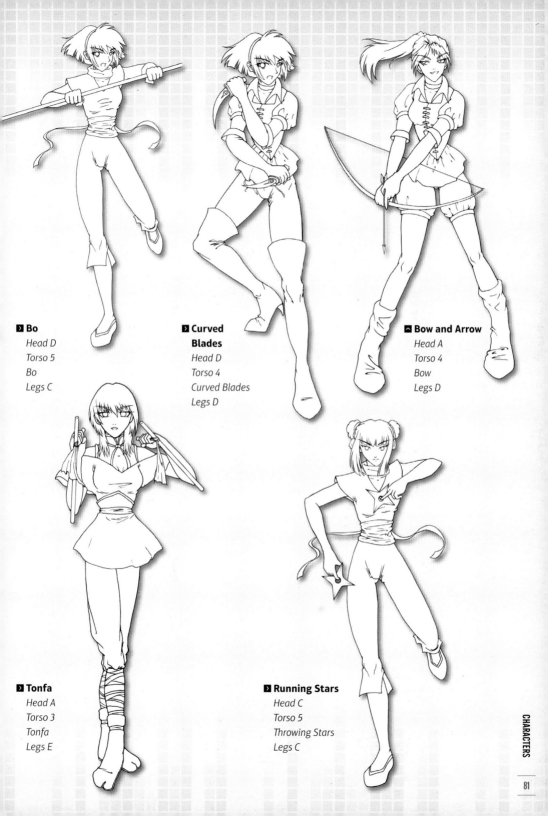

▶ Bo
Head D
Torso 5
Bo
Legs C

▶ Curved Blades
Head D
Torso 4
Curved Blades
Legs D

▲ Bow and Arrow
Head A
Torso 4
Bow
Legs D

▶ Tonfa
Head A
Torso 3
Tonfa
Legs E

▶ Running Stars
Head C
Torso 5
Throwing Stars
Legs C

MALE CHILD

Children form a large part of the manga and anime world, either as rapacious consumers or the stars of the show. At a conservative estimate (not allowing for the numerous possible combinations of accessories) this character has 25,000 possible variations.

LAYERS

◎◎	Accessory–Mad Glasses
⌐¬	Accessory–Glasses
◍	Accessory–Tear
▬▬	Accessory–Thin Glasses
◡	Accessory–Halo
✣	Accessory–Logo
◠	Accessory–Hat
⌒⌒	Expressions 1
⌒⌒	Expressions 2
⌒⌒	Expressions 3
⌒⌒	Expressions 4
⌒⌒	Expressions 5
	Hair 1
	Hair 2
	Hair 3
	Hair 4
	Hair 5
	Top 1
	Top 2
	Top 3
	Top 4
	Top 5
	Accessory-Small Wings

	Accessory–Ears
	Accessory–Shoe Chain
	Accessory–Wings
	Legs A
	Legs B
	Legs C
	Legs D
	Legs E

◀ **Angry Boy**
Expression 4
Hair 3
Top 5
Legs E

◥ **Menace**
Expression 1
Hair 1
Top 1
Legs A

CHARACTERS

82

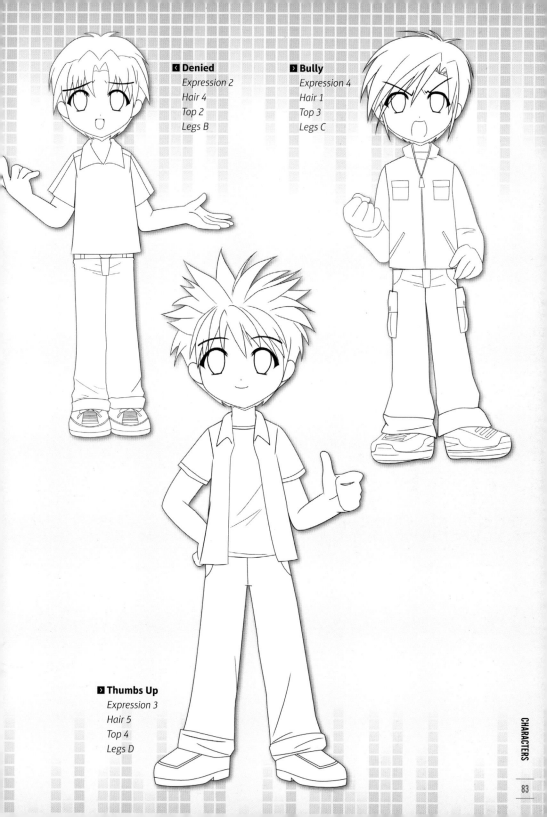

◄ Denied
Expression 2
Hair 4
Top 2
Legs B

► Bully
Expression 4
Hair 1
Top 3
Legs C

► Thumbs Up
Expression 3
Hair 5
Top 4
Legs D

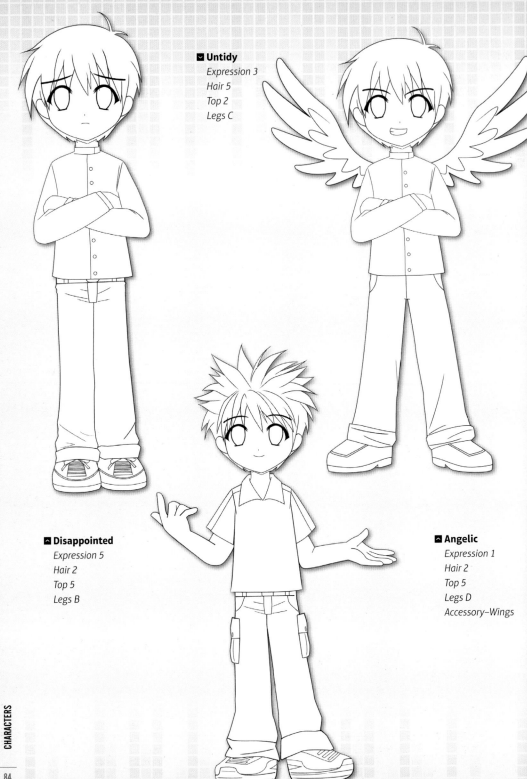

Untidy

Expression 3
Hair 5
Top 2
Legs C

Disappointed

Expression 5
Hair 2
Top 5
Legs B

Angelic

Expression 1
Hair 2
Top 5
Legs D
Accessory–Wings

▾ Evil Genius
Expression 1
Hair 2
Top 3
Legs A
Accessory–Mad Glasses, Hat

▾ Angelic Cat
Expression 3
Hair 4
Top 4
Legs B
Accessory–Halo, Small Wings, Ears

▴ Dude
Expression 3
Hair 1
Top 1
Legs E
Accessory–Thin Glasses

FEMALE CHILD

There are more than 25,000 possible variations of this character. Many are made simply by picking separate expressions and hair, rather than using a combined head layer. Many more are possible if you combine the accessories.

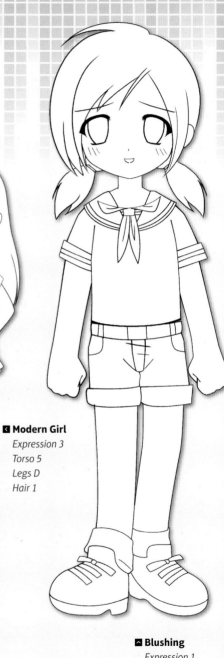

LAYERS

	Accessory–Bow
	Accessory–Tie
	Accessory–Halo
	Accessory–Lace Hair Band
	Accessory–Headband
	Accessory–Umbrella
	Accessory–Apple
	Expression 1
	Expression 2
	Expression 3
	Expression 4
	Expression 5
	Accessory—Hat
	Torso 5
	Torso 4
	Torso 3
	Torso 2
	Torso 1
	Legs A
	Legs B
	Legs C
	Legs D
	Legs E

	Hair 5
	Hair 4
	Hair 3
	Hair 2
	Hair 1
	Accessory–Giant Ears
	Accessory–Wings
	Accessory–Cat Ears
	Accessory–Ice-Cream
	Accessory–Lollypop
	Accessory–Giant Hair Bow

◄ **Modern Girl**
Expression 3
Torso 5
Legs D
Hair 1

↗ **Blushing**
Expression 1
Torso 4
Legs E
Hair 3
Accessory–Tie

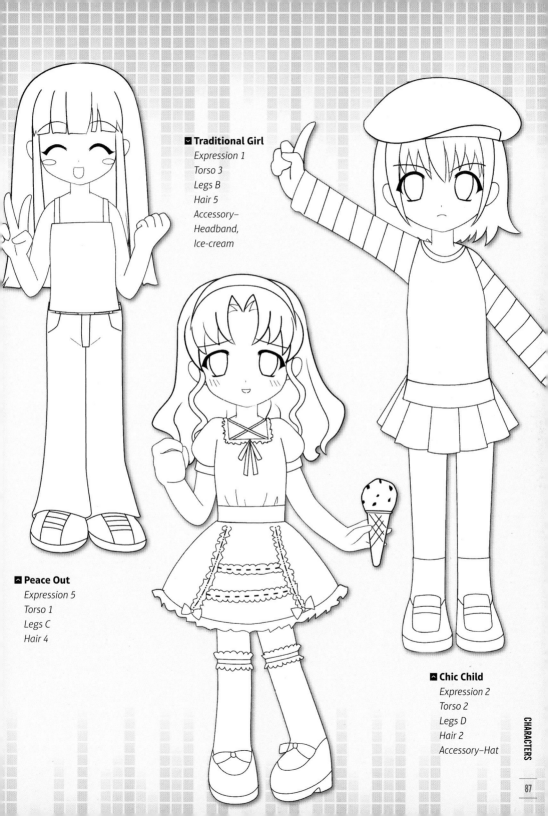

☑ Traditional Girl

Expression 1
Torso 3
Legs B
Hair 5
Accessory–
Headband,
Ice-cream

⌃ Peace Out

Expression 5
Torso 1
Legs C
Hair 4

⌃ Chic Child

Expression 2
Torso 2
Legs D
Hair 2
Accessory–Hat

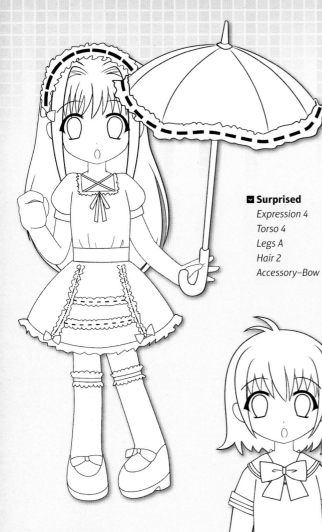

☑ Surprised

Expression 4
Torso 4
Legs A
Hair 2
Accessory–Bow

⬈ Summer Girl

Expression 4
Torso 3
Legs B
Hair 1
Accessory–Umbrella,
Lace Hairband

⬈ Good Girl

Expression 3
Torso 5
Legs E
Hair 3
Accessory–Apple

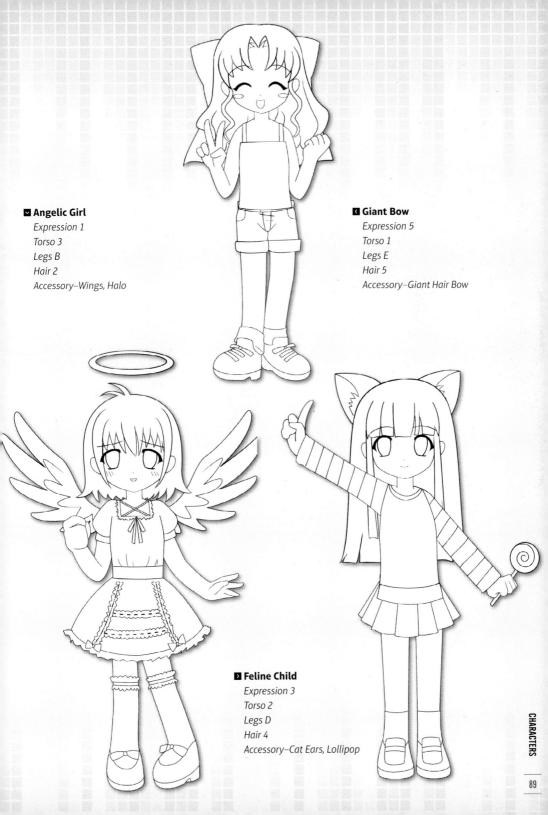

☑ Angelic Girl

Expression 1
Torso 3
Legs B
Hair 2
Accessory–Wings, Halo

◄ Giant Bow

Expression 5
Torso 1
Legs E
Hair 5
Accessory–Giant Hair Bow

► Feline Child

Expression 3
Torso 2
Legs D
Hair 4
Accessory–Cat Ears, Lollipop

CHIBI FEMALE

The Chibi—which translates both as "child" and "short person"—is a distinct manga style. Beyond simply depicting a child, these characters are stylized with puppy-dog eyes, little in the way of hands (they often look as if they are wearing mittens), and a mischievous look. There are approximately 25 million possible variations of this character.

▶ Cute Chibi

Eyes 1.1
Mouth 2
Headgear 1
Hair Sides 3
Head 5
Accessory 2
Upper 1
Lower 3.1, 3.2

LAYERS

Eyes 4.4	Mouth 14	Head 2		Lower 2.1
Eyes 4.3	Mouth 13	Head 1		Lower 1.1
Eyes 4.2	Mouth 12	Headgear 2.2		Lower 5
Eyes 4.1	Mouth 11	Accessory 15		Lower 4
Eyes 3.6	Mouth 10	Accessory 14		Lower 3.2
Eyes 3.5	Mouth 9	Accessory 13		Lower 2.2
Eyes 3.4	Mouth 8	Accessory 12		Lower 1.2
Eyes 3.3	Mouth 7	Accessory 11		Accessory 5
Eyes 3.2	Mouth 6	Accessory 10		Hair Back 5.2
Eyes 3.1	Mouth 5	Accessory 9		Hair Back 5.1
Eyes 2.6	Mouth 4	Accessory 8		Hair Back 4.4
Eyes 2.5	Mouth 3	Accessory 7		Hair Back 4.3
Eyes 2.4	Mouth 2	Accessory 6		Hair Back 4.2
Eyes 2.3	Mouth 1	Accessory 4		Hair Back 4.1
Eyes 2.2	Headgear 4	Accessory 3		Hair Back 3.1
Eyes 2.1	Headgear 3	Accessory 2		Hair Back 2.2
Eyes 1.6	Headgear 2.1	Accessory 1		Hair Back 2.1
Eyes 1.5	Headgear 1	Upper 5		Hair Back 1.2
Eyes 1.4	Hair Sides 3	Upper 4		Hair Back 1.1
Eyes 1.3	Hair Sides 2	Upper 3		
Eyes 1.2	Head 5	Upper 2		
Eyes 1.1	Head 4	Upper 1		
Mouth 15	Head 3	Lower 3.1		

◀ Girl Guide Chibi
Eyes 4.3
Mouth 12
Hair Sides 2
Headgear 3
Head 5
Upper 1
Lower 3.1, 2.2
Accessory 1, 9

▶ Fighting Chibi
Eyes 4.3
Mouth 3
Head 5
Accessory 6, 11, 12, 13
Upper 2
Lower 3.2

◀ Cape Chibi
Eyes 1.1
Mouth 12
Headgear 1
Head 3
Upper 2
Lower 3.1
Lower 2.2
Accessory 5

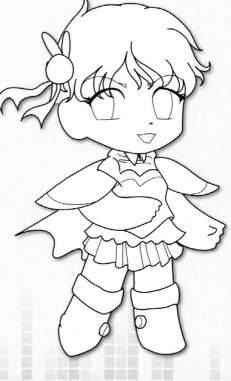

▶ Uniform Chibi
Eyes 4.2
Mouth 8
Headgear 4
Head 4
Upper 5
Lower 1.2

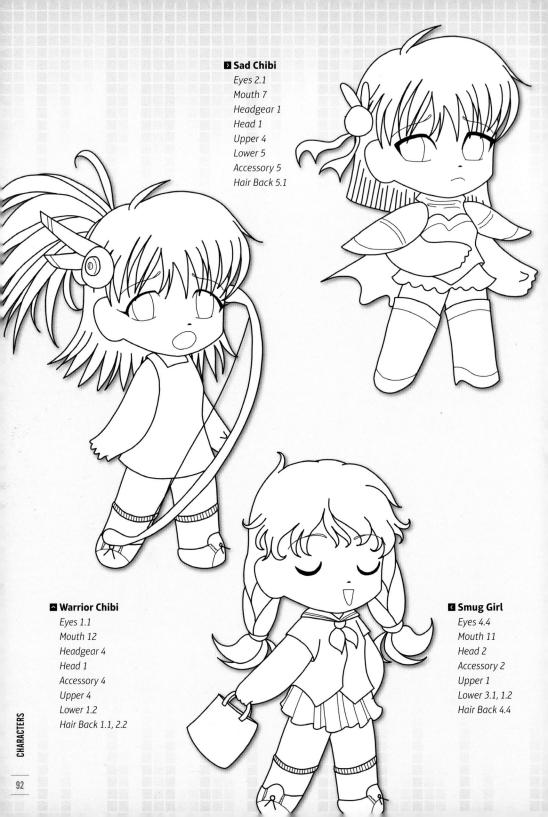

▶ Sad Chibi

Eyes 2.1
Mouth 7
Headgear 1
Head 1
Upper 4
Lower 5
Accessory 5
Hair Back 5.1

▲ Warrior Chibi

Eyes 1.1
Mouth 12
Headgear 4
Head 1
Accessory 4
Upper 4
Lower 1.2
Hair Back 1.1, 2.2

◀ Smug Girl

Eyes 4.4
Mouth 11
Head 2
Accessory 2
Upper 1
Lower 3.1, 1.2
Hair Back 4.4

▶ Shopping Chibi

Eyes 3.1
Mouth 13
Head 2
Accessory 7, 10, 11
Upper 53
Lower 4
Hair Back 2.1

▼ Mercury Chibi

Eyes 3.5
Mouth 4
Headgear 2.1
Head 5
Accessory 3, 8, 12
Upper 5.3
Lower 2.1, 4
Hair Back 4.3

▲ Crying Chibi

Eyes 4.1
Mouth 5
Head 3
Upper 5
Lower 3.1, 4
Hair Back 4.1

◀ Shocked

Eyes 3.1
Mouth 14
Headgear 1
Head 5
Upper 5
Lower 3.2
Hair Back 3.1

CHIBI MALE

This character has 25,000 possible variations, many of which can be achieved by changing the eyes and mouth. For a traditional Chibi look, aim for the most mischievous look you can.

LAYERS

	Headgear 4
	Headgear 3
	Headgear 2.2
	Headgear 2.1
	Headgear 2
	Headgear 1
	Mouth 15
	Mouth 14
	Mouth 13
	Mouth 12
	Mouth 11
	Mouth 10
	Mouth 9
	Mouth 8
	Mouth 7
	Mouth 6
	Mouth 5
	Mouth 4
	Mouth 3
	Mouth 2
	Mouth 1
	Eyes 4.4
	Eyes 4.3

	Eyes 4.2
	Eyes 4.1
	Eyes 3.6
	Eyes 3.5
	Eyes 3.4
	Eyes 3.2
	Eyes 3.1
	Eyes 2.6
	Eyes 2.2
	Eyes 2.1
	Eyes 1.6
	Eyes 1.5
	Eyes 1.4
	Eyes 1.3
	Eyes 1.2
	Eyes 1.1
	head 5
	Head 4
	Head 3
	Head 2
	Head 1
	Accessory 5
	Accessory 4

	Accessory 4
	Accessory 3.1
	Accessory 3.2
	Accessory 3.3
	Accessory 2
	Accessory 1
	Upper 5
	Upper 4
	Upper 3
	Upper 2
	Upper 1
	Accessory 6
	Accessory 3
	Lower 5
	Lower 4
	Lower 3
	Lower 2
	Lower 1

◪ Ninja Chibi
Headgear 2.1
Mouth 10
Eyes 4.4
Head 1
Accessory 1
Upper 2
Accessory 6
Lower 3

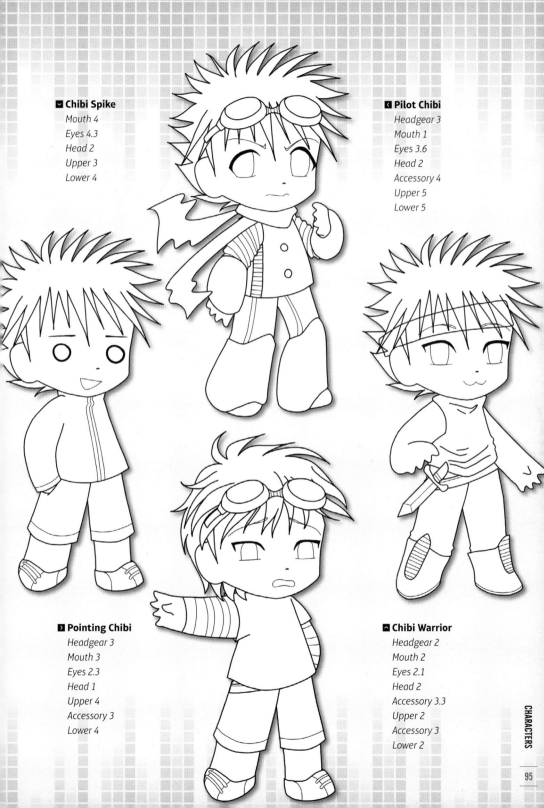

Chibi Spike
Mouth 4
Eyes 4.3
Head 2
Upper 3
Lower 4

Pilot Chibi
Headgear 3
Mouth 1
Eyes 3.6
Head 2
Accessory 4
Upper 5
Lower 5

Pointing Chibi
Headgear 3
Mouth 3
Eyes 2.3
Head 1
Upper 4
Accessory 3
Lower 4

Chibi Warrior
Headgear 2
Mouth 2
Eyes 2.1
Head 2
Accessory 3.3
Upper 2
Accessory 3
Lower 2

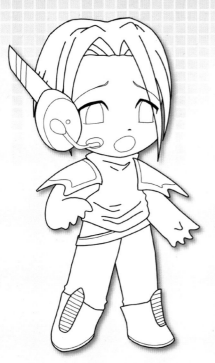

◄ Worried Chibi
Headgear 3
Mouth 7
Eyes 4.1
Head 3
Upper 3
Lower 3

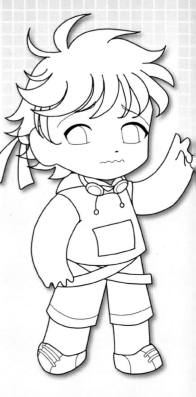

► Puzzled Chibi
Headgear 2.1
Mouth 15
Eyes 3.4
Head 3
Accessory 5
Upper 1
Accessory 6
Lower 4

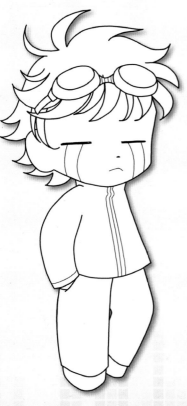

◄ Sad Chibi Boy
Headgear 3
Mouth 12
Eyes 4.2
Head 4
Accessory 3.1, 3.2
Upper 4
Accessory 6
Lower 1

► Helpful Chibi
Headgear 4
Mouth 6
Eyes 1.3
Head 4
Accessory 1
Upper 2
Accessory 3
Lower 2

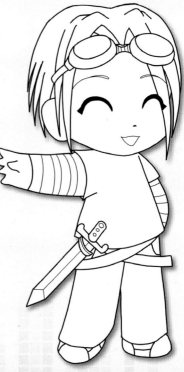

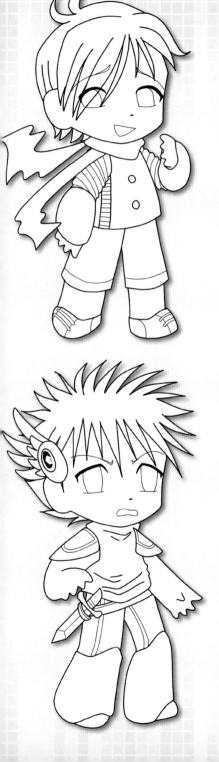

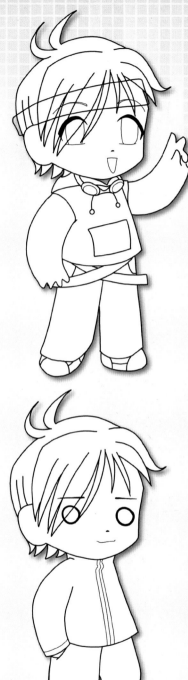

◄ Explorer Chibi
Mouth 4
Eyes 3.4
Head 5
Accessory 4
Upper 5
Lower 4

► Active Chibi
Headgear 2
Mouth 11
Eyes 3.1
Head 5
Accessory 5
Upper 1
Accessory 6
Lower 1

◄ Punk Chibi
Headgear 1
Mouth 3
Eyes 1.5
Head 2
Accessory 2, 3.1, 3.3
Upper 2
Accessory 3
Lower 5

► Casual Chibi
Mouth 10
Eyes 4.3
Head 5
Upper 3
Lower 3

GOOD MONSTERS

Here, both genders are included in one character.
However, individually placeable facial features and
22 accessories mean there are over 9.5 million
possibilities represented.

▶ Lion Man

Accessory 16, 19, 21, 22
Male Arms 1
Lower 4
Tail 2
Male eyes 4
Mouth 9
Head 8
Torso 1
Head 5, Back 1

LAYERS

	Accessory 22
	Accessory 21
	Accessory 19
	Accessory 18
	Accessory 17
	Accessory 16
	Accessory 15
	Accessory 14
	Accessory 13
	Accessory 12
	Accessory 11
	Accessory 9
	Accessory 8
	Accessory 6
	Accessory 5
	Accessory 3
	Accessory 2
	Accessory 1
	Accessory 7
	Accessory 10
	Male Arms 2
	Male Arms 1
	Lower 4

	Lower 3
	Lower 2
	Lower 1
	Tail 2
	Tail 1
	Male Eyes 7
	Male Eyes 6
	Male Eyes 5
	Male Eyes 4
	Male Eyes 3
	Male Eyes 2
	Male Eyes 1
	Mouth 16
	Mouth 15
	Mouth 14
	Mouth 13
	Mouth 12
	Mouth 11
	Mouth 10
	Mouth 9
	Mouth 8
	Mouth 7
	Mouth 6

	Mouth 5
	Mouth 4
	Mouth 3
	Mouth 2
	Mouth 1
	Female Eyes 8
	Female Eyes 7
	Female Eyes 6
	Female Eyes 5
	Female Eyes 4
	Female Eyes 3
	Female Eyes 2
	Female Eyes 1
	Ears 3
	Ears 2
	Ears 1
	Head 8
	Head 7
	Head 6
	Head 5
	Head 4
	Head 3
	Head 2

	Head 1
	Accessory 20
	Female Arms 2
	Female Arms 1
	Torso 3
	Torso 2
	Torso 1
	Head 5 back 2
	Head 5 back 1
	Head 4 back 2
	Head 4 back 1
	Head 2 back 2
	Head 2 back 1
	Head 1+3 back 2
	Head 1+3 back 1
	Accessory - wing bands
	Accessory - wings

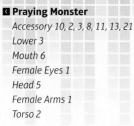

◄ Praying Monster
Accessory 10, 2, 3, 8, 11, 13, 21
Lower 3
Mouth 6
Female Eyes 1
Head 5
Female Arms 1
Torso 2

▶ Female Satyr
Accessory 10, 5, 21
Lower 1
Tail 1
Mouth 1
Female Eyes 3
Head 4
Female Arms 2
Torso 2
Head 4, Back 2

▲ Angel
Accessory 21, 18
Lower 3
Male Eyes 4
Mouth 1
Head 4
Female Arms 1
Torso 1
Head 4
Back 1
Accessory–Wings

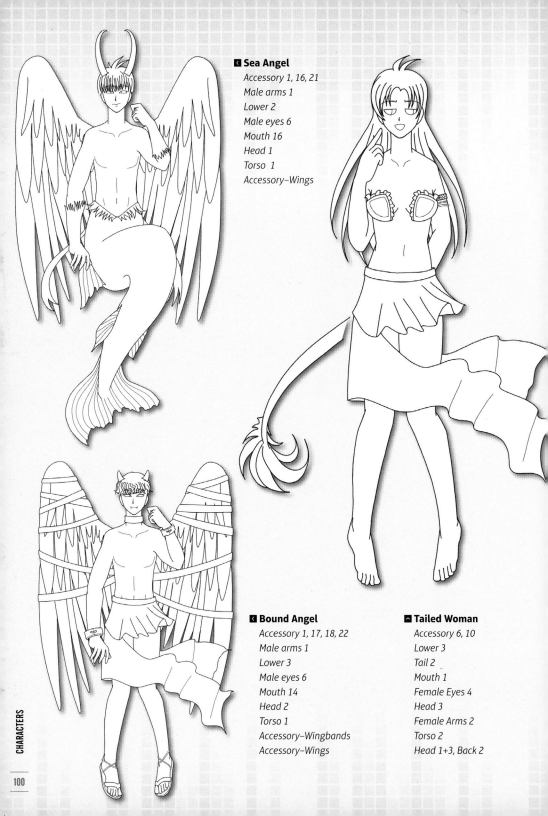

◄ **Sea Angel**
Accessory 1, 16, 21
Male arms 1
Lower 2
Male eyes 6
Mouth 16
Head 1
Torso 1
Accessory–Wings

◄ **Bound Angel**
Accessory 1, 17, 18, 22
Male arms 1
Lower 3
Male eyes 6
Mouth 14
Head 2
Torso 1
Accessory–Wingbands
Accessory–Wings

⬏ **Tailed Woman**
Accessory 6, 10
Lower 3
Tail 2
Mouth 1
Female Eyes 4
Head 3
Female Arms 2
Torso 2
Head 1+3, Back 2

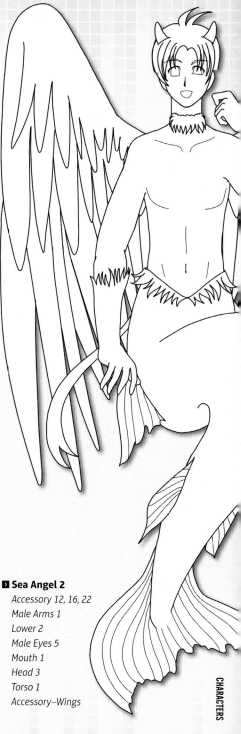

⬈ Satyr Angel

Accessory 11, 15, 21
Male Arms 2, 1
Lower 1
Male eyes 7
Mouth 2
Ears 2
Head 2
Torso 1
Head 2, Back 2
Accessory–Wings

▶ Feline Woman

Accessory 22, 7
Lower 4
Mouth 1
Female Eyes 4
Head 6
Female Arms 1
Torso 3

▶ Sea Angel 2

Accessory 12, 16, 22
Male Arms 1
Lower 2
Male Eyes 5
Mouth 1
Head 3
Torso 1
Accessory–Wings

EVIL MONSTERS

As with Good Monsters, both genders are included in the one character, while individually placeable facial features and accessories mean there are millions of possibilities.

LAYERS

Accessory 17	
Accessory 13	
Accessory 12	
Accessory 11	
Accessory 10	
Accessory 9	
Accessory 7	
Accessory 6	
Accessory 5	
Accessory 4	
Accessory 3	
Accessory 2	
Accessory 1	
Female Arms 2	
Female Arms 1	
Male Arms 2	
Male Arms 1	
Male Eyes 7	
Male Eyes 6	
Male Eyes 5	
Male Eyes 4	
Male Eyes 3	
Male Eyes 2	

Male Eyes 1	
Mouth 16	
Mouth 15	
Mouth 14	
Mouth 13	
Mouth 12	
Mouth 11	
Mouth 10	
Mouth 9	
Mouth 8	
Mouth 7	
Mouth 6	
Mouth 5	
Mouth 4	
Mouth 3	
Mouth 2	
Mouth 1	
Female Eyes 8	
Female Eyes 7	
Female Eyes 6	
Female Eyes 5	
Female Eyes 4	
Female Eyes 3	

Female Eyes 2	
Female Eyes 1	
Ears 6	
Ears 5	
Ears 4	
Ears 3	
Ears 2	
Ears 1	
Head 8	
Head 7	
Head 6	
Head 5	
Head 4	
Head 3	
Head 2	
Head 1	
Accessory 16	
Accessory 15	
Accessory 14	

Accessory 8	
Lower 3	
Lower 2	
Lower 1	
Tail 2	
Tail 1	
Torso 3	
Torso 2	
Torso 1	
Head 8 Back 2	
Head 8 Back 1	
Head 3 Back 1	
Head 2 Back 2	
Head 2 Back 1	
Head 1 Back 3	
Head 1 Back 2	
Head 1 Back 1	
Wings 1	

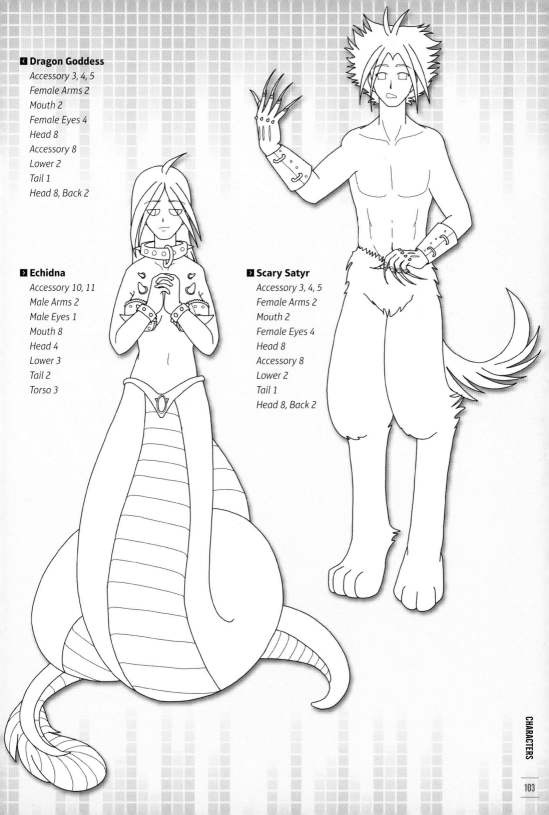

◀ **Dragon Goddess**
Accessory 3, 4, 5
Female Arms 2
Mouth 2
Female Eyes 4
Head 8
Accessory 8
Lower 2
Tail 1
Head 8, Back 2

▶ **Echidna**
Accessory 10, 11
Male Arms 2
Male Eyes 1
Mouth 8
Head 4
Lower 3
Tail 2
Torso 3

▶ **Scary Satyr**
Accessory 3, 4, 5
Female Arms 2
Mouth 2
Female Eyes 4
Head 8
Accessory 8
Lower 2
Tail 1
Head 8, Back 2

◄ **Dragon Man**
Accessory 1, 12
Male Arms 1
Male Eyes 4
Mouth 8
Ears 4
Head 6
Accessory 15
Lower 1
Torso 1
Wings 1

▲ **Dragon Girl**
Accessory 2, 3, 7
Female Arms
Mouth 2
Female Eyes 1
Head 1
Accessory 8
Lower 1
Tail 1
Torso 2
Head 1, Back 1

◤ Changing Man

 Accessory 9
 Male Arms 1
 Male Eyes 3
 Mouth 7
 Ears 1
 Head 5
 Lower 3
 Torso 3

◢ Winged Beast

 Accessory 6
 Accessory 4
 Female Arms 1
 Mouth 5
 Female Eyes 8
 Head 3
 Accessory 14
 Lower 3
 Tail 2
 Torso 2
 Head 1, Back 2

MECHAS

Mechanical monsters are every bit as exciting as their serpentine counterparts. This giant robot character has been designed so that an amazing array of accessories —from drills to rocket launchers—can be plugged into its shoulders, legs, or body armor. Let your imagination run riot.

LAYERS

Drill Arm						
Laser Cannon		Head 10		Legs 01b		**▲ Giant Mecha**
Shield		Head 11		Torso 05		*Head 1*
Laser Gun		Head 12		Torso 04		*Arms 3b*
Light Sword		Ears 01a		Torso 03		*Legs 1b*
Sword		Ears 02a		Torso 02		*Torso 1*
Machine Gun		Ears 03a		Torso 01		*Legs 1a*
Rocket Launcher		Ears 04a		Shoulders 05a		*Arms 3a*
Emblem		Ears 05a		Shoulders 04a		
Ears 01b		Shoulders 05b		Shoulders 03a		
Ears 02b		Shoulders 04b		Shoulders 02a		
Ears 03b		Shoulders 03b		Shoulders 01a		
Ears 04b		Shoulders 02b		Legs 05a		
Ears 05b		Shoulders 01b		Legs 04a		
Head 01		Arms 03b		Legs 03a		
Head 02		Arms 02b		Legs 02		
Head 03		Arms 01b		Legs 01a		
Head 04		Chain Arm 01		Arms 03a		
Head 05		Chain Arm 02		Arms 02a		
Head 06		Chain Arm 03		Arms 01a		
Head 07		Crane Arm		Backpack 01		
Head 08		Legs 05b		Backpack 02		
Head 09		Legs 04b		Backpack 03		
		Legs 03b		Backpack 04		

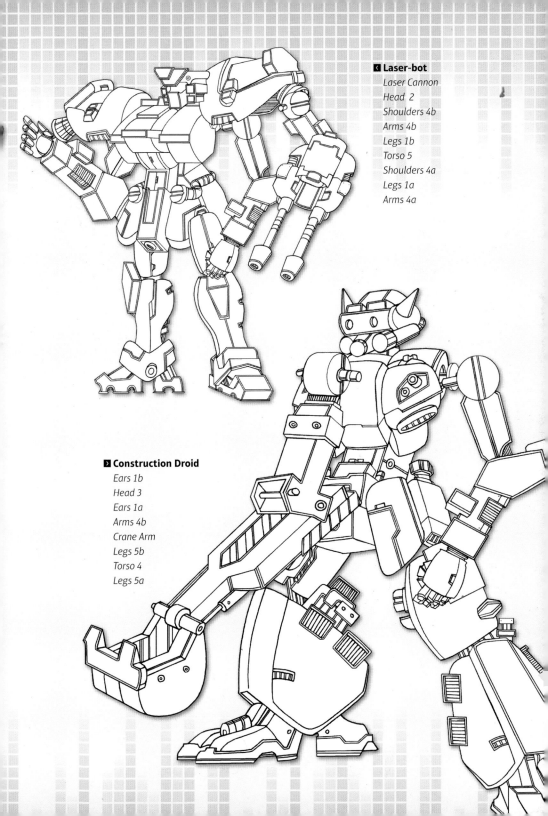

◄ Laser-bot

Laser Cannon
Head 2
Shoulders 4b
Arms 4b
Legs 1b
Torso 5
Shoulders 4a
Legs 1a
Arms 4a

► Construction Droid

Ears 1b
Head 3
Ears 1a
Arms 4b
Crane Arm
Legs 5b
Torso 4
Legs 5a

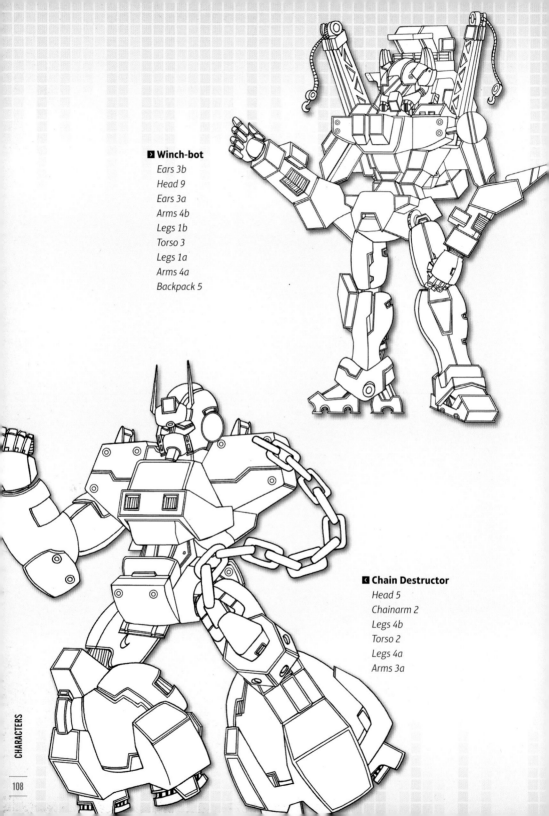

▶ Winch-bot

Ears 3b

Head 9

Ears 3a

Arms 4b

Legs 1b

Torso 3

Legs 1a

Arms 4a

Backpack 5

◀ Chain Destructor

Head 5

Chainarm 2

Legs 4b

Torso 2

Legs 4a

Arms 3a

CHARACTERS

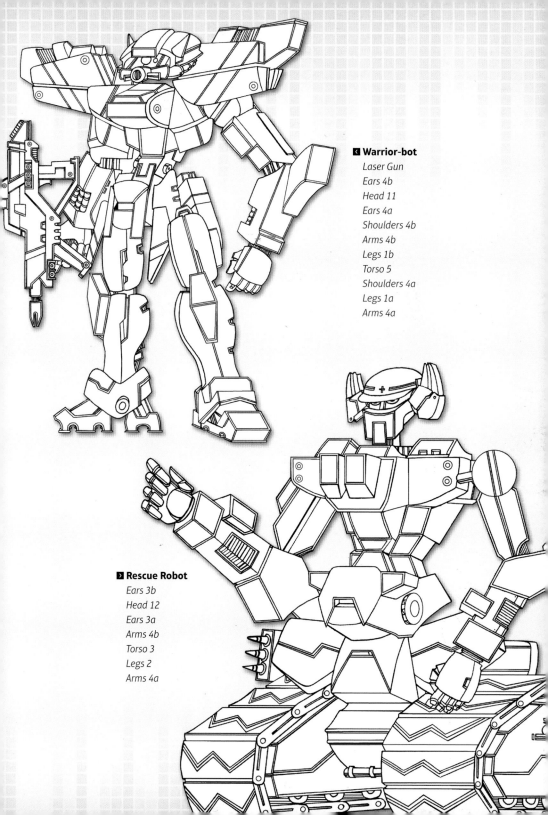

◂ Warrior-bot
Laser Gun
Ears 4b
Head 11
Ears 4a
Shoulders 4b
Arms 4b
Legs 1b
Torso 5
Shoulders 4a
Legs 1a
Arms 4a

▸ Rescue Robot
Ears 3b
Head 12
Ears 3a
Arms 4b
Torso 3
Legs 2
Arms 4a

ALTERNATIVE STYLES

CUTE BOY

This Cute Boy adds a touch of whimsy to your line-art collection. With 54 variations, there are a surprising number of options from this uncomplicated character. Select one layer from the heads, one from the legs, and one of the three body layers. There are then two alternative sets of arms for each body layer—these are the two arm layers immediately above their respective bodies.

▶ Boy with Puppy
Head 2
Arms 2
Body 3
Legs 1

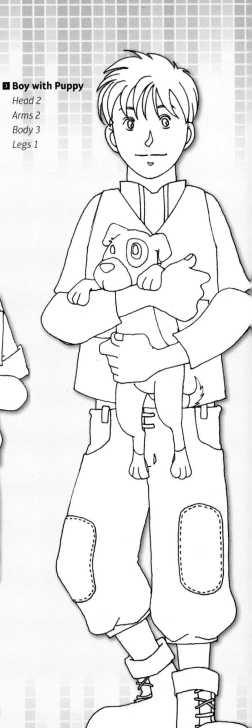

LAYERS

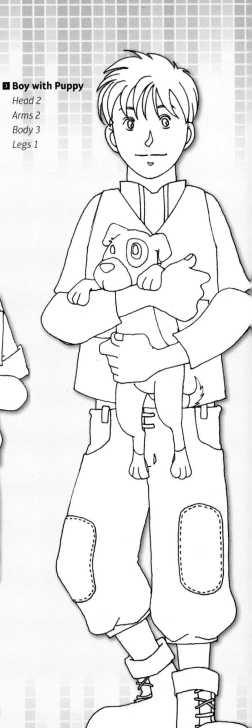	Head 03
	Head 02
	Head 01
	Arms 01
	Arms 02
	Body 01
	Arms 03
	Arms 04
	Body 02
	Arms 05
	Arms 06
	Body 03
	Legs 03
	Legs 02
	Legs 01

▶ Enthusiastic Reader
Head 3
Arms 1
Body 1
Legs 3

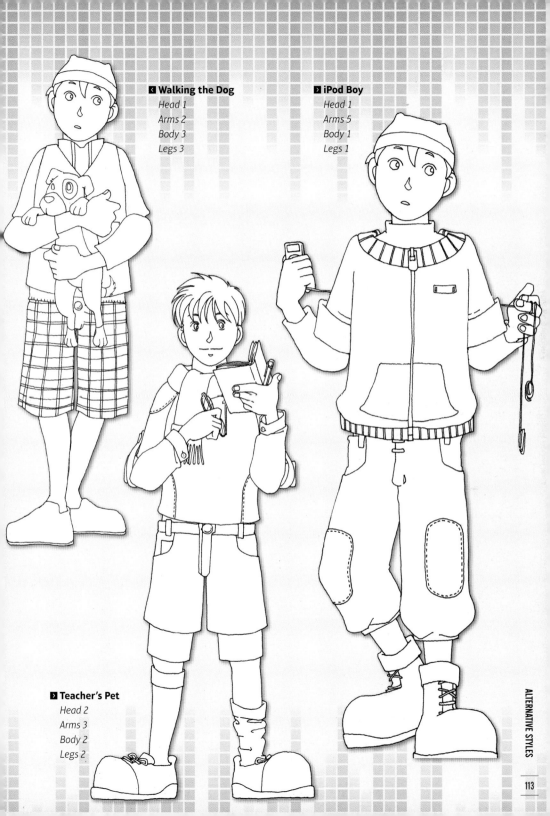

◀ **Walking the Dog**
Head 1
Arms 2
Body 3
Legs 3

▶ **iPod Boy**
Head 1
Arms 5
Body 1
Legs 1

▶ **Teacher's Pet**
Head 2
Arms 3
Body 2
Legs 2

CUTE GIRL

With a little more vintage glamour than the Contemporary Female, the Cute Girl offers another 63 variations. Select one layer from the heads, one from the legs, and one of the three body layers. There are then two or three choices of arms for each body—these are the yellow layers above their respective blue body layers.

LAYERS

	Head 1
	Head 3
	Head 2
	Arms 3.2
	Arms 3.1
	Body 3
	Arms 2.3
	Arms 2.2
	Arms 2.1
	Body 2
	Arms 1.2
	Arms 1.1
	Body 1
	Legs 1
	Legs 2
	Legs 3

❭ Wall Flower
Head 2
Arms 2.3
Body 2
Legs 2

❭ Going Out
Head 1
Arms 3.2
Body 3
Legs 1

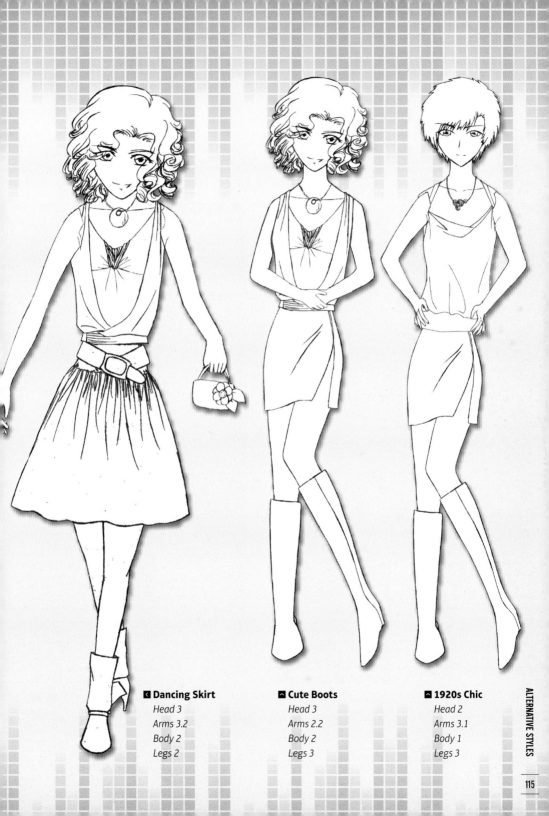

◀ **Dancing Skirt**

Head 3
Arms 3.2
Body 2
Legs 2

◥ **Cute Boots**

Head 3
Arms 2.2
Body 2
Legs 3

◥ **1920s Chic**

Head 2
Arms 3.1
Body 1
Legs 3

MONSTERS

With 18 possible variations, this monster manages to look vicious and supremely cool at the same time.

LAYERS

	Head 1
	Head 2
	Head 3
	Body 1
	Body 2
	Body 3
	Legs 1
	Legs 2
	Legs 3

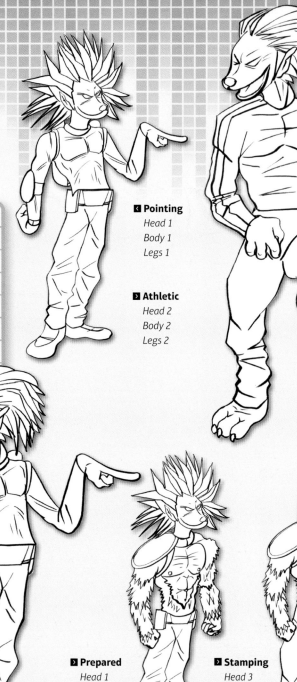

◁ **Pointing**
Head 1
Body 1
Legs 1

▷ **Athletic**
Head 2
Body 2
Legs 2

▷ **Commanding**
Head 2
Body 1
Legs 1

▷ **Prepared**
Head 1
Body 3
Legs 1

▷ **Stamping**
Head 3
Body 3
Legs 2

ALIENS

Again, 18 possible variations can be achieved with this cheerful bug-eyed monster.

LAYERS

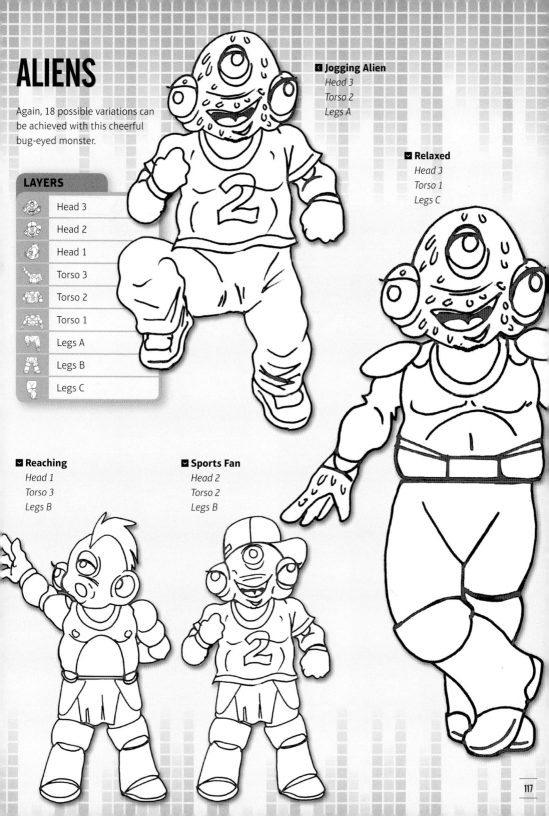	Head 3
	Head 2
	Head 1
	Torso 3
	Torso 2
	Torso 1
	Legs A
	Legs B
	Legs C

◁ **Jogging Alien**
Head 3
Torso 2
Legs A

☑ **Relaxed**
Head 3
Torso 1
Legs C

☑ **Reaching**
Head 1
Torso 3
Legs B

☑ **Sports Fan**
Head 2
Torso 2
Legs B

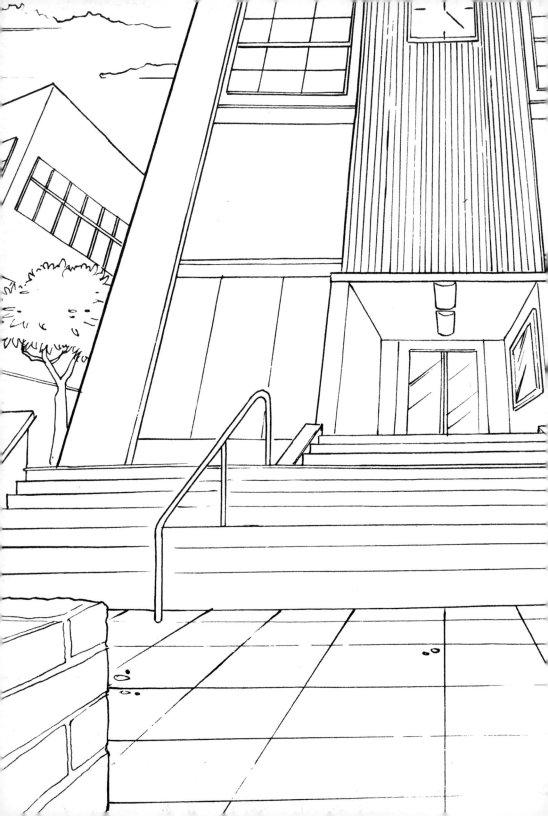

BACKGROUNDS & ACCESSORIES

BACKGROUNDS

Volcano

A Terran volcano? An alien planet? With those sharp, jagged rocks and stylish, angular clouds, this doesn't look like an environment to raise kids in. Then again, it might be just their idea of fun!

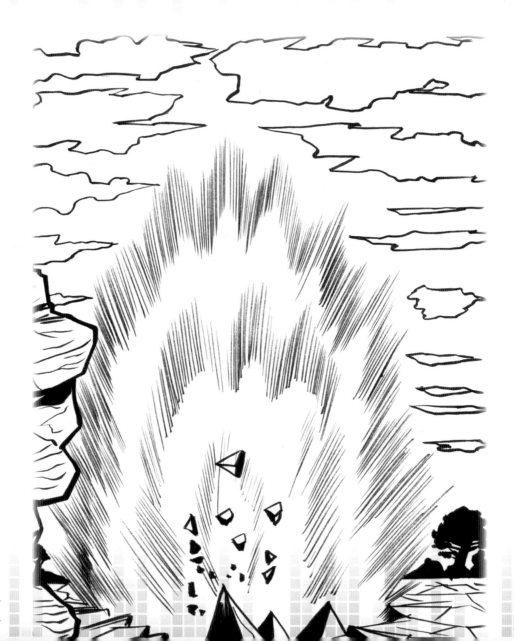

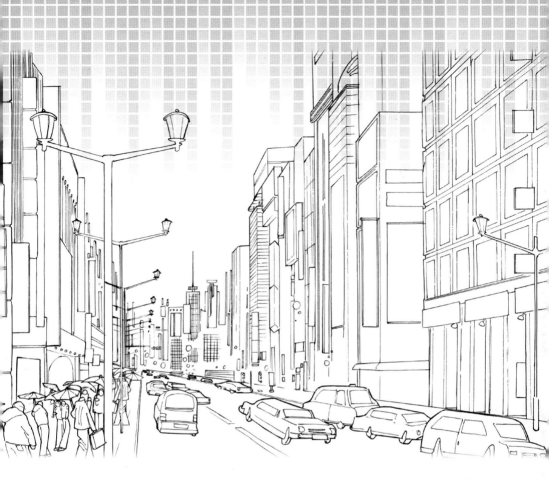

City Street

A classic street scene, with the
added bonus that you can color it
yourself to create bright daylight,
dreary rain, or murky night. Too
many people? Simply switch off
the cars or the crowd layers for
a more deserted feel.

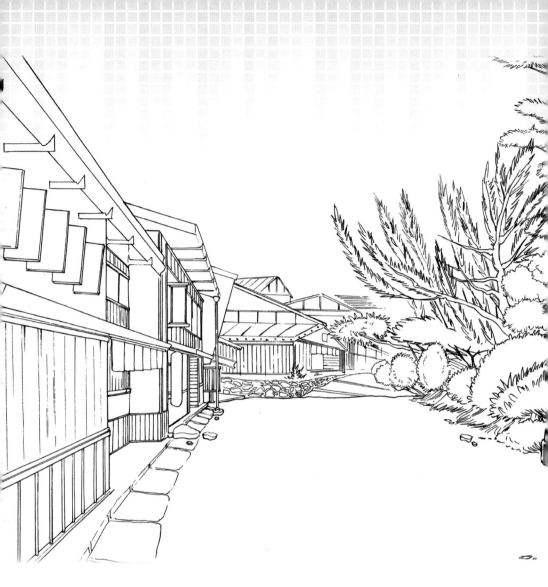

Village

A classic Japanese community, featuring tightly packed, stylized homes and strictly maintained gardens. What better environment for your characters to relax in?

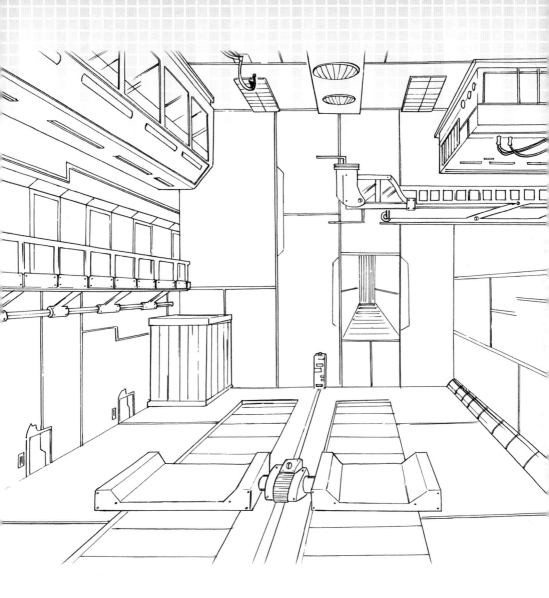

Hangar

This industrial hangar is a conveniently ambiguous
environment. With the right characters it could
become a disused factory, or the site of a battle
between futuristic robots. It could even be their
production line.

Schoolyard

This iconic schoolyard design would be a great background for some of the Child or Chibi characters, but with more adults around it could just as easily look like a university campus.

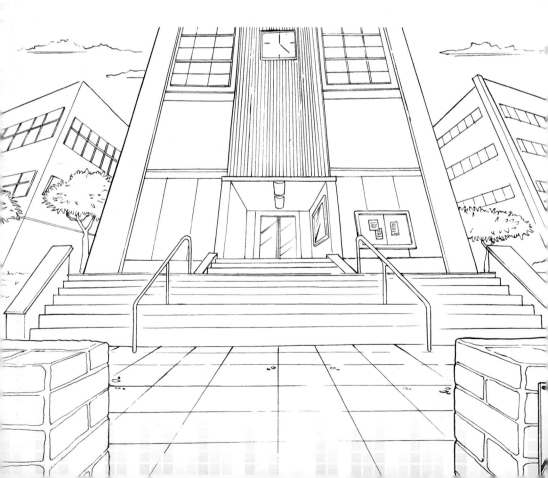

Waterfront

An industrial dockside could easily be the present or the not-too-distant future. You can affect its overall atmosphere with your choice of colors.

ACCESSORIES

You can add any of these accessories to your images by cutting them out and copying them using one of the selection tools. For more detailed instructions, turn to page 23.

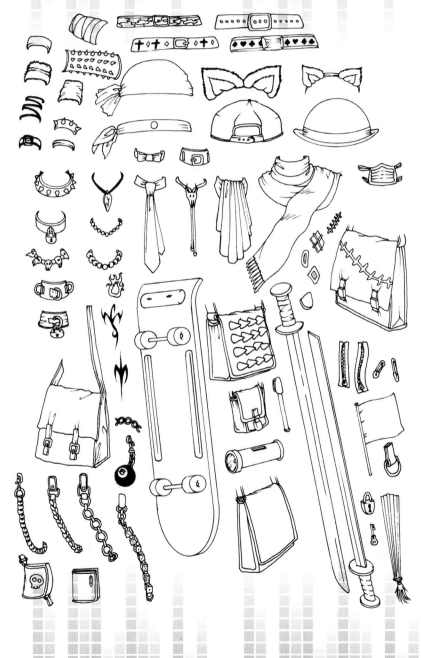

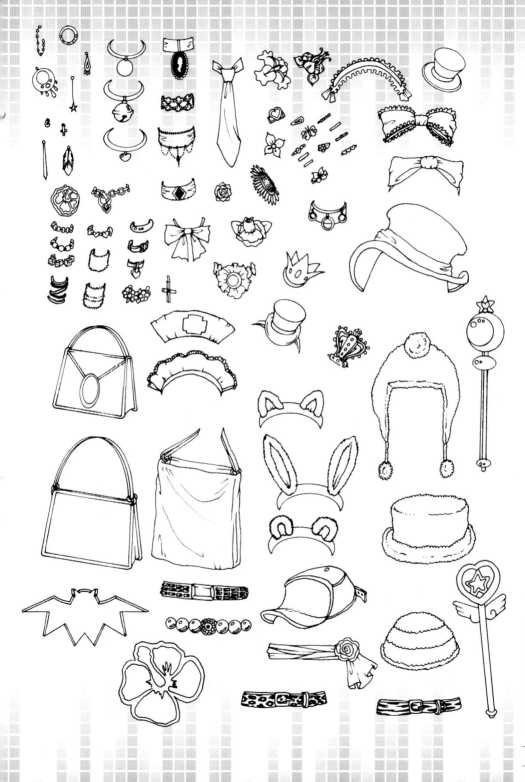

CONTRIBUTORS

HAYDEN SCOTT-BARON

Hayden, aka Dock, is a professional video-games artist, focusing on character design and 3D graphics. He has created art and scripts for several manga graphic novels and character illustrations for books, games, magazines, and advertisements. He is the co-founder of Sweatdrop Studios, a group of artists producing manga-style comics.

SELINA DEAN

Selina Dean is a freelance illustrator, specializing in manga illustrations. She produced her first commission for promotional fliers when she was 15 and decided drawing and getting paid for it was pretty good. She is a founding member of Sweatdrop Studios. Her own comics include the drama series *Fantastic Cat*, the surreal fantasy comic *Fantasma*, and a variety of short stories. She has also contributed to several articles and books about manga.

ALEISTER KELMAN

Aleister is a freelance illustrator and designer with a love of all things Japanese. His projects range from character design to storyboarding, fashion illustration to corporate web design. He is a member of Sweatdrop Studios, with a number of comics to his name.

SONIA LEONG

Sonia is a freelance artist and illustrator specializing in anime and manga. She is a member of Sweatdrop Studios, and participates in industry workshops on manga. Sonia works in a variety of media, including watercolor, pen and ink, screentone, alcohol color markers, pencils, and digital.

KELLY HE

Jia-wei He (Kelly) traveled to the UK from China to study business. Unable to resist drawing, she now creates manga as part of the Birmingham-based group Hi8Us, giving her the base from which to publish a comic.

LAURA WATTON

Laura Watton has been drawing manga for over 12 years, and is one of the founding members of Sweatdrop Studios. Her illustrations have been published in various national UK magazines, including *Shout*, *Just 17*, and *Neo*.

WING YUN MAN

Wing Yun Man is a freelance artist specializing in anime and manga-style illustration. Her artwork has been featured in various websites, magazines, and books, including the manga anthology *Sugardrops*.

MICHAEL STEARNS

Michael Stearns is an illustrator who likes giant robots too much, and feels that true mecha comes from within. Although the future is terrifying and uncertain, Michael hopes that it contains a version of himself as a happy and successful game developer. His first (finished) videogame, *SkyPuppy*, is available online.

JOHN MCCREA

John McCrea has been drawing comics for 18 years, working for publishers including Marvel and DC. He has drawn Batman, Superman, Wonder Woman, the Hulk, Spider-Man, Daredevil, Wolverine, Star Wars, Judge Dredd, and the Simpsons, among others. John has worked as an illustator for books, records, magazines, and movie storyboards, and he teaches on the side in schools and colleges.

MICHIRU MORIKAWA

Michiru is an illustrator and cartoonist who has seen her career blossom since moving from Japan to the UK. Her work, inspired by British children's books, picked up the coveted International Manga and Anime Festival (IMAF) grand prize in 2005 for her unique and original style. She has been called "a very rare talent."